IMAGES
of America

EARLY KIRKLAND

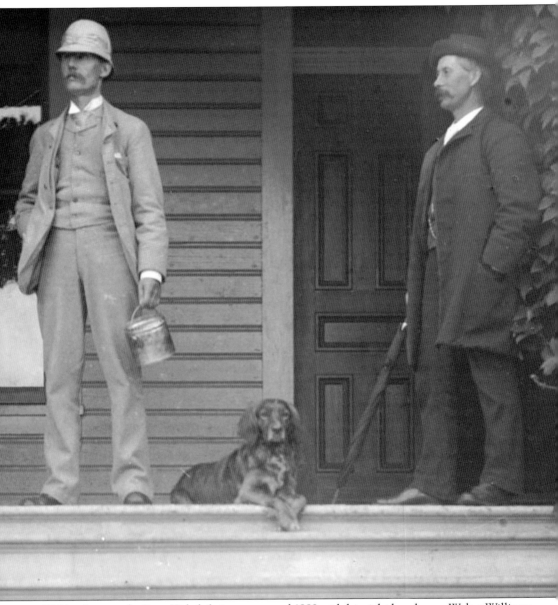

Kirkland namesake Peter Kirk, left, is seen around 1889 with his right-hand man, Walter Williams, his UK corporation's secretary who joined him in launching his US ventures. Visionary salesman's salesman S.J. "Leigh" Hunt—Hunt's Point namesake, *Post-Intelligencer* newspaper owner, and political boss—persuaded Kirk to locate his steel mill and company town on Lake Washington, envisioning a "Pittsburgh of the Pacific." (Kirkland Heritage Society.)

ON THE COVER: Houghton pioneer Caroline French (1827–1909) poses with an umbrella as the 96.5-foot steamboat *Kirkland* chugs southward. French, her husband, Samuel "Foss" Foster, and grown son Harry came to the Washington Territory in 1872. Their house was located at 10120 NE Sixty-Third Street. This shot may have been taken in February 1889, when the *Kirkland* transported a US Navy commission on a tour to determine Lake Washington's suitability as a navy yard. The Navy eventually chose Bremerton instead. (Kirkland Heritage Society.)

IMAGES
of America

EARLY KIRKLAND

Matthew W. McCauley

ARCADIA
PUBLISHING

Published by Arcadia Publishing
Charleston, South Carolina

Printed in the United States of America

Library of Congress Control Number: 2017952565

For all general information, please contact Arcadia Publishing:
Telephone 843-853-2070
Fax 843-853-0044
E-mail sales@arcadiapublishing.com
For customer service and orders:
Toll-Free 1-888-313-2665

Visit us on the Internet at www.arcadiapublishing.com

For Sarah.

CONTENTS

ACKNOWLEDGMENTS

I would like to thank Sarah and Benjamin Behrendt, and Dave Behrendt for his editorial assistance; Cameron and Jake McCauley, and William J. McCauley for his editorial assistance; Glenn Landguth and the Kirkland Heritage Society (KHS) for access to its collection; and in particular, Loita Hawkinson of KHS for her fact-checking, and photograph and editorial assistance. Thanks go to Mike and Vicki Elwell and the Higginbotham family; Jana Robertson; Anita Maxwell and the Gilbert family; Barbara Loomis and the late Bob Burke; Rob Butcher and Kirklandviews.com; Mary Harris and Rebecca Willow of Parkplace Books; Alan Stein; Eastside historian Tom Hitzroth for sharing photographs, documents, and his amazing research; Molly (McAuliffe) Bishop, Janice (McAuliffe) La Haye, and the McAuliffe family; Sue and Santos Contreas; Dr. Lorraine McConaghy; the late Russ McClintick Sr.; the late Geneva Hutchinson; Grant Barrie and the late Mabel and Don Barrie; the late Dorris (Forbes) Beecher, JoAnne (Forbes) Deligan, and the Forbes family; Dave Davis and the French family; Jan (Etzler) Strode and the Etzler family; Doug Williams and the Williams family; Deb Healy and the Burke family; Patty (Fessenden) Sullivan Behrendt, Warren Fessenden and the Clark/Patty family; Laurie Klemmedson and the Brooks family; Doug Morgan and the late Florence and Chuck Morgan; Sonia and Brian Curtis and the Curtis and Northup families; the late Arline Andre; the late Dick and Patty Shinstrom; the late Al Locke; Kent Sullivan, Northern Pacific Railway Historical Association (NPHA.org); Rebecca Pixler and Janette Gomes, King County Archives; Julie Irick, Seattle Municipal Archives; and the City of Kirkland, particularly Mark Padgett of Public Works.

The Kirkland Heritage Society's collection served as the primary source of images for *Early Kirkland*. Other images in this volume appear courtesy of the King County Archives (KCA), the Seattle Municipal Archives (SMA) and the Northern Pacific Railroad Historical Association (NPRHA). Unless otherwise noted, all images are courtesy of the Kirkland Heritage Society.

INTRODUCTION

Today, Kirkland is a city of nearly 88,000, situated opposite Seattle on the eastern side of the state's second largest lake, Lake Washington. While conforming to the realties of tremendous regional population growth, it has retained its small town feel in its downtown business district and boasts an impressive roster of nearly 50 parks. Churches of many faiths, a keen interest in public and private art, strong public school and youth athletics programs, numerous community festivals and celebrations, a robust collection of service clubs, avid volunteerism, lively local politics, and a sense of civic pride all contribute to Kirkland's high quality of life today.

Kirkland lies in the Puget Sound Lowland, a topographic basin situated between the Cascade and Olympic mountain ranges. Over the past 2.5 million years, massive glaciers have scoured the land, deposited debris, and retreated in a slow, repeating cycle. Geologists call the most recent ice sheet that covered the Puget Sound Lowland the Puget Lobe of the Cordilleran Ice Sheet. The lobe filled the Lowland basin about 17,500 years ago and retreated about 1,000 years later during what they term the Vashon period of the Fraser glaciation. Scientists believe at its thickest point, the ice blanketing the Kirkland area was about 3,000 feet thick—about equivalent to five Seattle Space Needles stacked atop one another.

The glaciers gouged out a series of deep troughs, which trend north-south. Puget Sound, Lake Washington, the Sammamish Valley, and Lake Sammamish were all scoured by vast quantities of meltwater beneath the glaciers. As the ice withdrew, piles of soil and rock, called till and drift, were deposited as north-south ridges. We have assigned names to those ridges—Big Finn Hill, Little Finn Hill, and Rose Hill, among others.

Geologists who have studied core samples taken from the bottom of Lake Washington believe there was a period after the ice withdrew during which the lake was a marine embayment—that it was salt-water filled, and connected to Puget Sound at its south end by a trough running west to the saltwater-filled trough that became the Duwamish River Valley, which was then an extension of Elliott Bay. Eventually, the Cedar River deposited sufficient material at the lake's south end to create a large delta that ended the saltwater incursion. As today, the lake was then fed with fresh water at the north by the Sammamish River and rising freshwater created an outflow, later called the Black River, at the south end, which flowed into the Duwamish River and then into Puget Sound.

As the ice receded, the exposed till and drift were quite barren, but over time, hearty plants sprung up in ever increasing numbers, and soon, animals followed to feed on those. Scientists believe that humans, descendants of people who had earlier crossed into North America from Asia, arrived here about that time as well and over time the harsh conditions softened and likely became an open parkland of lodgepole pine and spruce, grasses, and bracken fern, interspersed with hazel and cedar. About 7,800 years ago, the climate shifted and became cooler and moister. That change resulted in a dense, closed canopy forest of western red cedar, western hemlock, and Douglas fir, with cottonwood on the floodplains.

The indigenous peoples adapted to these changes and over millennia developed cultures centered on hunting, fishing, and gathering. There is still much for researchers to learn about how they lived and organized their societies. Three small native settlement sites have been reported in today's Kirkland: at the mouth of Juanita Creek, downtown Kirkland, and on Yarrow Bay. (In 1993, the author interviewed the late Dorris [Forbes] Beecher. She grew up during the 1910–1920s in the Forbes House, at today's Juanita Beach Park, and described finding arrowheads in that area.)

By the early 1800s, the indigenous residents were Puget Salish people who identified tribally as Duwamish, as were the occupants of present-day Seattle. Those dwelling in today's Kirkland were Sammamish, a subgroup of the Duwamish. These people sustained themselves by hunting large game such as deer and elk, and small game and fowl. Fish was a dietary mainstay, and salmon were in abundance. They also gathered berries and wild plants for food and medicinal uses.

The Denny Party arrived on Puget Sound in November 1851 from Illinois through Oregon to found Seattle. From about the 1850s, regional explorers, a few hermit-like fur trappers, survey crews, and itinerant lumbermen explored and worked the eastern shore of Lake Washington, then called Lake Duwamish, or the unflattering Lake Duwamps. But these men did not put down roots here; they came to find and exploit natural resources such as timber and minerals.

Prior to 1916, Lake Washington was nine feet higher than today, and the now-extinct Black River drained its southern end, where it joined the Cedar River and then merged with the White River to become the Duwamish River, which flowed into Elliott Bay through a substantial mudflat. Lake Washington was first mentioned by Puget Sound pioneer Isaac Ebey, who guided his cedar dugout canoe up the Duwamish River. Curious about what he would find, he pushed forward and followed the fork up the Black and then into a massive lake, which he christened Lake Geneva because of its clarity, depth, and the beauty of its setting.

The earliest recorded Eastside exploration—the notes of the first government land survey teams—gives a sense of Kirkland as wilderness. Because the general land office of the federal government was to offer these lands for homestead, it was critical that the land be included in the public land survey system, which divided areas into six-mile squares called townships. Each township comprised 36 one-mile-square sections. Only after these boundaries were established could settlers identify the exact land parcels they were claiming under the various homestead acts.

While some people today have an image of the pre-settlement Eastside as a pristine, magnificent old-growth natural paradise, the facts do not support this conjecture. Survey notes mention large areas of burned timber and old-growth Hemlock and Douglas Fir intermingled with smaller, young trees of those and other species. Many trees were down, presumably by the wind.

The mighty, deep-rooted Douglas fir thrived, but crop varieties did not find the Kirkland-area soil hospitable. Because land was then largely valued for its agricultural potential, much of the soil around Kirkland was described in surveys between 1855 and 1870 as second- and, most often, third-rate. In the following decades and into the early 20th century, many Kirklanders scratched out a hardscrabble living on their stump ranches, some raising chickens, others cultivating hardy berry species in the poor soil. It appeared in those early days that the area around Lake Washington could offer settlers little but timber.

In September 1870, the Eastside townships were resurveyed and described in this way: "This township affords an abundance of timber, fir, cedar, hemlock on the high lands and spruce, maple and alder on the low lands. In the low lands of a productive nature various kinds of plants abound—wild cabbage, wild parsnips, coarse grass. And on the high lands, fern, red and black whortleberry, salmon berry, and Oregon grapes."

This survey foreshadowed a new era in the history of Kirkland's settlement. *Early Kirkland* explores Kirkland's first decades through images. Not intended as a comprehensive history, it is instead a nostalgic glimpse at the people and events that made Kirkland the Eastside's most historic city.

One

PIONEERS

This 1867 nautical chart depicts Lake Washington and vicinity as the early American settlers found it. The lake was referred to as Lake Dwamish, which was a corruption of the native Lushootseed name of the tribe occupying the area. It was then nine feet higher than it is today, and the now-extinct Black River drained it at the site of modern Renton, eventually flowing into Elliott Bay after joining the Duwamish River. At this time, Seattle was a tiny village near the Duwamish River mudflats. The Eastside had been explored by government survey teams, loggers, and some of Seattle's more adventuresome residents, but was unsettled other than the beginnings of coal-mining activity at Newcastle. There had been native settlements decades earlier, but those were gone by this time other than at the mouth of the Black River. In 1870, the federal government made the Eastside available to homesteaders, and things began to change. (National Oceanic and Atmospheric Administration.)

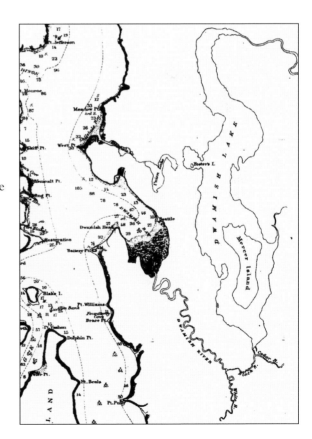

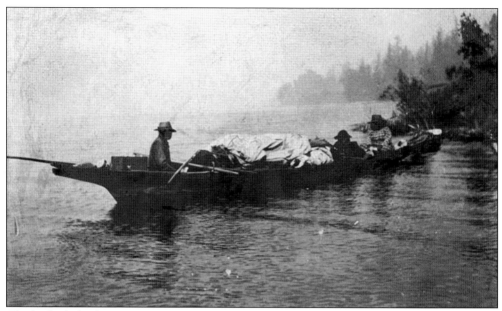

Cheshiahud, also known as "John" (pictured below with his second wife, Tleebuleetsa, also known as "Madeline") was a Duwamish man born about 1820 in a village on Lake Washington. He was one of the few Lake Washington natives to have been photographed. This image was captured by Orion O. Denny, the son of Seattle cofounders Arthur and Mary Ann (Boren) Denny, and O.O. Denny Park's namesake. Cheshiahud carved canoes and is seen above in one of his creations, likely photographed on Lake Union or Lake Washington. He was well regarded as a friend to the white settlers and, like other Duwamish who worked and lived among the settlers, took refuge in the blockhouse and stockade with them during the January 1856 Battle of Seattle, when settlers were attacked by Nisqually and other native peoples. In the 1870s, Cheshiahud lived with his first wife, Sbeilddot, also known as Lucy Annie, and their two children near where Mercer Slough enters Lake Washington. She died in 1885, and he relocated to land at the south end of Portage Bay, spending the last few years of his life with his daughter and her family near Port Madison. Tleebuleetsa and Cheshiahud died in 1906 and 1910, respectively.

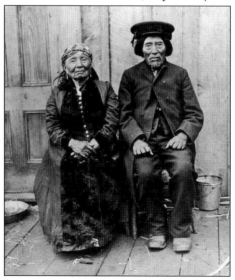

Chief Seattle (c. 1786–1866) is the anglicized name of the popular Duwamish leader, Si'ahl, who befriended many of Seattle's first settlers. Tradition holds that his father was a Suquamish tribal leader and his mother was born in a Duwamish camp on the Black River, which drained Lake Washington through today's Renton prior to the lake being lowered nine feet in 1916. He had eight children; his daughter, whose name in the Lushootseed language is debated, was known to settlers as Princess Angeline. She was born about 1820 on Lake Washington, near today's Rainier Beach. In her later years, she lived in a cabin in Seattle on Western Avenue between Pike and Pine Streets. She was also well liked by white residents and supplemented her income by selling photographs of herself. These images seem to have been quite popular; several of Kirkland's pioneer families owned them. Her and her father's likenesses were also popular on postcards. Si'ahl died in 1866 and was buried in Suquamish Memorial Cemetery. Angeline died in 1896 and rests in Seattle's Lake View Cemetery.

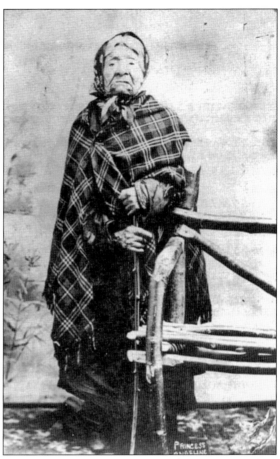

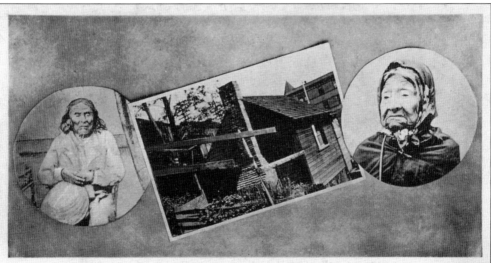

Chief Seattle & Princess „Angeline" and home of „Angeline". Seattle, Washington

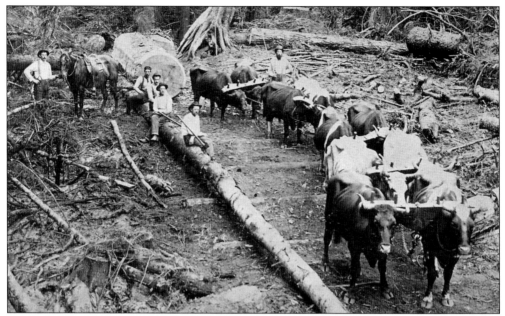

On the heels of the first explorers and surveyors, loggers were the next group to pass into today's Kirkland in the mid-19th century. This began with "hand logging," whereby the trees closest to the lake were cut and then pulled with block and tackle and other human-powered methods into the lake, where they could be taken by water to the western side and pulled out to nearby sawmills. After the trees closest to the water were cut, loggers ventured further inland, but this required teams of horses or yokes of oxen to skid the logs out to the lake. A common practice is shown here; a type of corduroy road, known as a skid road, was created by placing logs perpendicular to the direction of travel, and then horses or oxen were employed to pull the logs out of the woods across the greased skids. The skids were kept greased by a crew member, often a boy, who was called a "grease monkey." Logging using these methods was extremely dangerous for both the men and animals involved; injury and death were quite common. Though not the stuff of television or film dramas, a man in the old Pacific Northwest was far more likely to die in a logging accident than he was in a gunfight or by the hand of a hostile native.

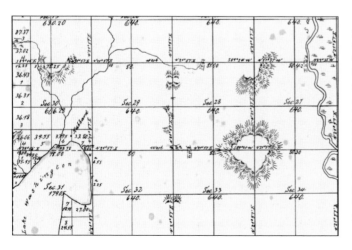

A portion of the General Land Office cadastral map of Township 26/Range 5E created from an 1870 survey shows the cabin of 18-year-old Martin Hubbard near Juanita Bay as the only dwelling north of Yarrow Bay. Henry Goldmyer, also 18 or 19 years old, staked his claim at the bay's east edge a short time prior to Hubbard, who was likely Kirkland's first permanent homesteader. (National Archives.)

The Juanita Bay shore is pictured before the lake was lowered nine feet in 1916. Today's 98th Avenue NE and the wetlands surrounding it were all covered by water, and the shoreline at the bay's head was about as far northeast as today's Forbes Creek Drive.

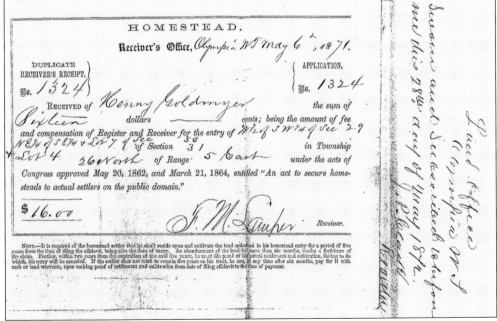

Henry Goldmyer's 1871 homestead receipt is pictured here; he received title in 1872. Goldmyer did not keep his land long. According to Kirkland researcher Loita Hawkinson, by June 1873, Seattle pioneer Charles Terry's widow, Mary Terry, and her new husband, William Gilliam, owned the land, and Hawkinson credits her with choosing the name Juanita. She died in 1875, and her heirs owned a portion of the property into the 20th century. (Tom Hitzroth.)

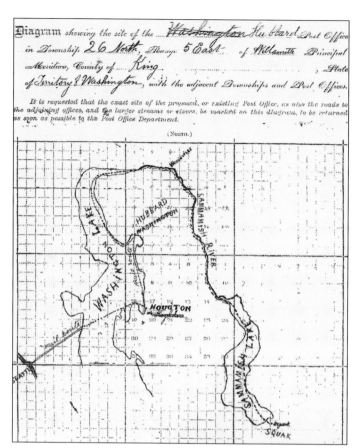

Pictured is part of Martin Hubbard's 1881 application to establish a post office and formally name the settlement. Though the name Juanita was in use, Hubbard tried to rename it Washington, but that was rejected as too common, so Hubbard was chosen. In 1886, it was officially recognized as Juanita. (Tom Hitzroth and National Archives.)

Hubbard's mail route was lengthy; he rowed to Madison Park, then walked to Seattle to get the mail. He then walked back, rowed across to Houghton, and started deliveries. He then headed north, delivering mail to settlers as he went, up the Sammamish River—substantially more winding, brushy, and windfallen-log strewn—then on to Woodinville, all the way down to Issaquah, and back home. He later drowned in a logging accident on Juanita Bay.

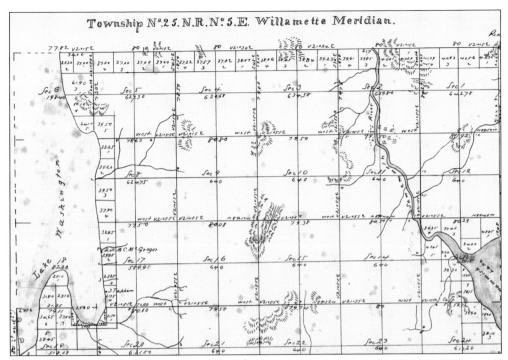

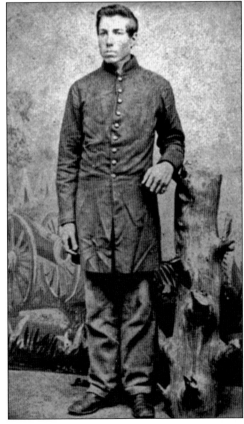

This 1870 Township 25/Range 5 East General Land Office cadastral map reveals a raw, mostly uninhabited area. Homesteader James Popham, misprinted on the map as "Tapham," who staked 167 acres, is shown, as is his mother, Nancy McGregor, who had 143 acres. Brother William Thomas "Tom" Popham's 161-acre claim was located south of James's land, but he did not have a dwelling noted on the survey. (National Archives.)

Jay C. O'Conner (1846–1910) was another early Houghton arrival. He staked an 80-acre claim and became a pioneer Lake Washington steamboat operator. Like many Eastside pioneers, O'Conner was a Civil War veteran. He is seen here during the war. He enlisted in 1864 at age 17, serving in M Company of the 1st Wisconsin Heavy Artillery. He and his wife, Eve, came to the Washington Territory in 1872.

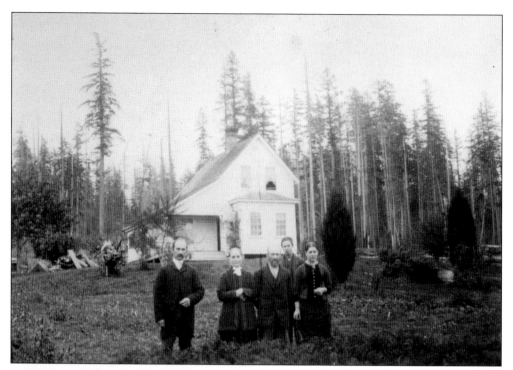

Houghton's French family is seen here in front of their home, built in 1874. From left to right are Harry, Caroline, Samuel "Foss," and Lucy Tuttle. The young man in the back is not identified, but may be a member of the Tuttle family. Lucy was of mixed native and white blood. When the family experienced difficulties, some of the children were taken in by neighbors. Lucy lived for a time with the Frenches.

Native resident Quolitza Luihut "Anna" (Kennum) Tuttle was the daughter of Mary "Tyee Mary" Kennum, a Duwamish, and George Snatelum, a Skagit, who married about 1845. Abner was a Mexican War veteran who came west during the 1849 gold rush. The two married in 1860 and lived near the Black River; by the early 1870s, they were living in Houghton with their children.

Frontier marriages between native women and white men were quite common in the 1850s and 1860s, but somewhat frowned upon by the Seattle social establishment. Lucy Ann (Tuttle) Stamp (c. 1863–1954) was the product of such a union, and a woman whose maternal lineage likely spanned hundreds of generations on Lake Washington. She married Edwin Stamp in 1886 in a civil ceremony officiated in Houghton by pioneer justice of the peace John DeMott.

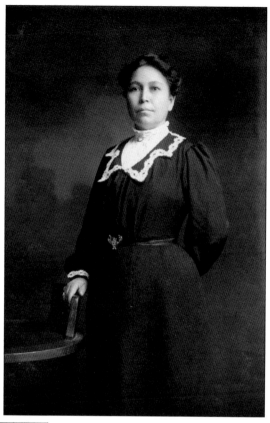

Houghton pioneer Harry D. French (1849–1937) is seen in the 1910s in front of the Eastside's first frame house, which he built on his Houghton homestead in 1874, at 10120 NE Sixty-Third Street. French was instrumental in organizing Kirkland's first church, Kirkland Congregational United Church of Christ, and was one of the Kirkland Cemetery's founding trustees.

17

The French house is seen here in its original location in 1889 or 1890. This frontier clearing later became 10120 NE Sixty-Third Street. The French house was saved from demolition and moved in 1978. It is now located at 4130 Lake Washington Boulevard.

Harry French was an early amateur photographer. He captured this image of Houghton from Hunt's Point around 1889. The road leading into the dense forest went all the way to Redmond; today, it is NE Fifty-Second Street. The white home on the lake from which the road originates was owned by the pioneer Frank and Molly Curtis family.

Settlers initially called today's Yarrow Bay "Pleasant Bay," and the community was known by that name. When postal authorities required a single-word name, Edison was chosen, but it was rejected since another community had taken the name. Harry French's May 29, 1881, journal entry confirms that the name Houghton was then chosen to honor church benefactor Sarah Jane Houghton of Boston, who purchased the congregation a bell.

May 29th

The people of this place have finally decided to call it Houghton complimentary to Mrs Houghton of Boston whose husband & Mr Dennison gave us a fine Bell weight ? for our church. We had to change the name of our place formerly called Pleasant Bay as the Post office authorities at Wash D.C. objected to on account of its being a double name.

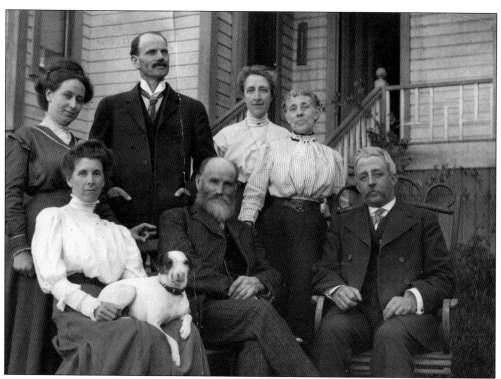

Houghton's pioneer Frank and Mollie Curtis family pose around 1900 in front of their home, located just south of Carillon Point. From left to right are (first row) Anna (Curtis) Eisenbeis, James Franklin "Frank" Curtis, and Frederick Eisenbeis; (second row) Mary Jane (Sanderson) Curtis, Walter King Curtis and wife Louise M. (Eisenbeis) Curtis, and Mary Matilda "Mollie" (King) Curtis.

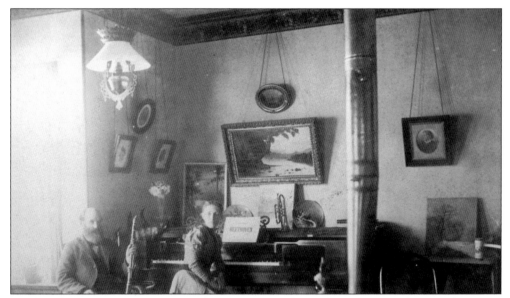

Frank and Mollie Curtis are seen in their home on Lake Washington around 1895. The Curtis Family was quite musical, and members of the family played different instruments. Mollie was well known as a superb piano player and taught music at the University of Washington. (Sonia and Brian Curtis.)

The Curtis family homes are seen from Lake Washington. Frank and Mollie's home was on the left; Frank's aunt and uncle Nancy and William Curtis lived in the home at right, which had also served as Houghton's first post office. The puncheon road, made of split logs, was then the only land means to travel along that section of shoreline. (Sonia and Brian Curtis.)

James T. Curtis (1810–1896), pictured here in the 1890s, came west with wife Sophia (1814–1899) and grown children William, Frank, and Sophia (Curtis) Northup via covered wagon from South Dakota; they settled first in Seattle and relocated to Houghton in the 1870s. The Curtis sons were renowned steamboat men—as builders, owners and crew. They were amazingly nautical, especially considering they came from South Dakota. (Sonia and Brian Curtis.)

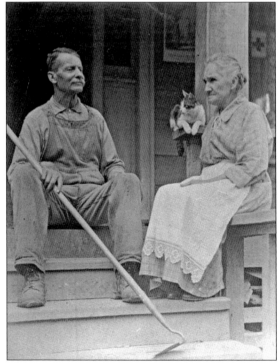

Curtis daughter Florell (1853–1928) and her husband, Civil War veteran Benson Northup (1845–1926), settled south of her family in the northern part of today's Bellevue in an area once called Northup. It was centered about where Northup Road crosses under State Route 520 today. Benson was a writer and printer who launched a newspaper in Seattle in 1878 called the *Seattle Post* that was later merged with the *Intelligencer* to form the *Seattle Post-Intelligencer*. (Sonia and Brian Curtis.)

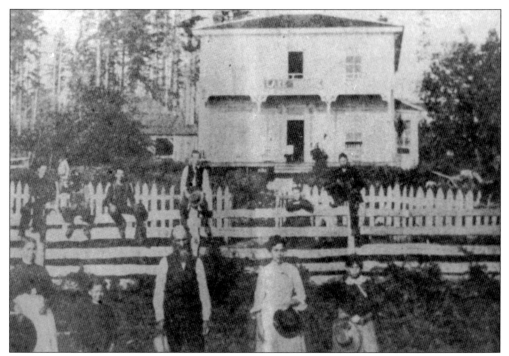

Lake House was a hotel catering primarily to travelers headed between Seattle and Redmond. Originally built in the early 1880s by Jay and Eve O'Connor, they sold it in 1884 to John and Abigail Fish (at front center with their daughter Bessie). It remained in the family for several generations, continuing as a hotel until after World War II, when it was used as the Kirtley family's home. It stood at 10127 NE Fifty-Ninth Street and was demolished in 1984. (Kirtley Collection, KHS.)

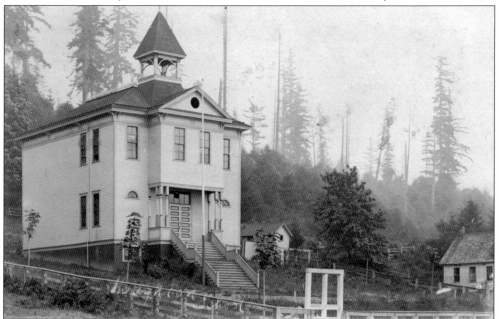

The Houghton school stood on the lakeshore adjacent to and south of the Curtis property. The school stood just south of today's Carillon Point, at about the 4800 block of Lake Washington Boulevard.

Martin Clark was a shoemaker who came to Seattle from Iowa in about 1877 with his wife, Eliza, and daughters two-year-old Sarah and four-year-old Ora. They staked a claim near Green Lake, where son, Willis, was born. In 1882, they sold rights to their claim and staked a new one—152 acres in today's Highlands Neighborhood in 1882, where another daughter, Lucy also known as "Lutie," was born that year. (Patty [Fessenden] Bernhardt.)

In the District Court of the Third Judicial District of Washington Territory, holding terms at Seattle, in King County, for the counties of King and Kitsap;

HOMESTEAD AFFIDAVIT

Under Section 2294, Revised Statutes, for settlers who cannot appear at the District Land Office.

Office of the Clerk of the Court

For *Seattle King* County,

March 12, 1883.

I, *Martin H. Clark*, of *King County Wash. Territory* being about to having filed my Homestead Application No. *4750*, do solemnly swear that *I am a native born Citizen of the United States of America — the head of a family consisting of a wife and four (4) children*

that said application No. *4750* is made for the purpose of actual settlement and cultivation; that said entry is made for my exclusive use and benefit, and not, directly or indirectly for the use or benefit of any other person or persons whomsoever; that *I am* now residing on the land I desire to enter, and that I have made a *bona fide* improvement and settlement thereon; that said settlement was commenced *October 1st 1882* that my improvements consist of *a Cabin residence, 3 acres cleared, and road opened up* and that the value of the same is $ *200 00/00*; that owing to *the distance being* *over 75 Miles*

I am unable to appear at the District Land Office to make this affidavit, and that I have never before made a homestead entry ~~except~~

Martin H. Clark.

Sworn to and subscribed before me this *12th* day of *March*, 1883.

James P Ludlow Dep. Clerk of the Court for *Said* Court.

NOTE.—The claimant must fill up the blank places above, showing whether he is the head of a family or over twenty-one years of age; whether a native citizen, or has declared his intention to become a citizen; whether he and his family, or some member thereof, is residing on the land, giving the date of actual settlement, describing the dwelling-house and improvements, and stating the value of the same, and stating reason for not appearing at the District Land Office. If claimant ever before made a homestead entry, describe the same; if not, draw a line over the word "except."

[III59—30,000.]

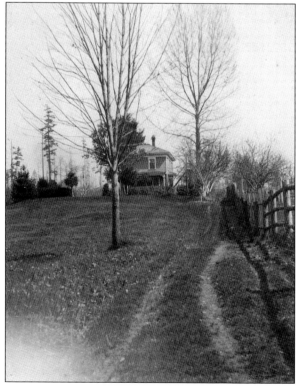

By November 1890, the Clarks had sold much of their original 154-acre homestead claim, platted the remainder as the Lake Avenue Addition to Kirkland, and built a frame home on what was then called Moreton Avenue (later renamed Fifteenth Avenue). Peter Kirk Elementary occupies the site today. (Patty [Fessenden] Bernhardt.)

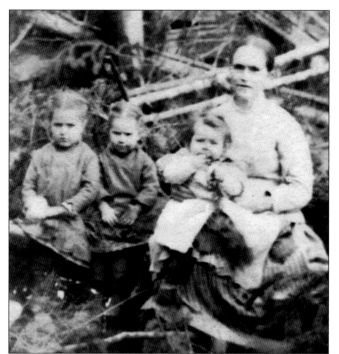

From left to right, Lutie, Margaret, Walter, and Eliza Clark are pictured in 1887. In 1882, a diphtheria outbreak claimed the lives of all three older siblings, and only baby Lutie survived. Over a few unimaginably horrible days, before their parent's eyes and despite their desperate efforts, nine-year-old Ora, seven-year-old Sarah, and three-year-old Willis perished one by one in the cabin. They were buried near the cabin but now rest with their parents in the Kirkland Cemetery. (Patty [Fessenden] Bernhardt.)

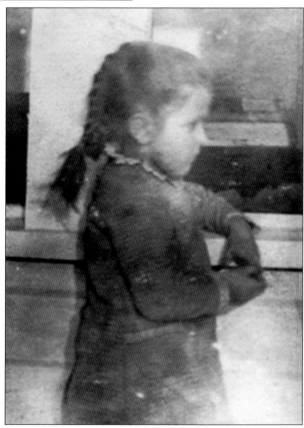

Lutie Clark is seen here as a little girl on the family homestead in today's Highlands Neighborhood. By this time, she had had two younger siblings: Charles (who also went by "Walter") and Margaret. (Patty [Fessenden] Bernhardt.)

Baby Lutie Clark survived the diphtheria that killed her siblings and grew into a beautiful young woman, seen at right in 1904. In 1902, she was one of Kirkland's newly built Union "A" High School's first graduates, and in 1905—the year Kirkland incorporated as a town—she married Ollis Patty, Kirkland's first city treasurer. The two had four children, and many of their descendants remain in the Kirkland area today. Below, in the 1930s, Lutie is seen with her adult daughters Alice Fessenden (left) and Stella Patty. (Both, KHS and Patty [Fessenden] Bernhardt.)

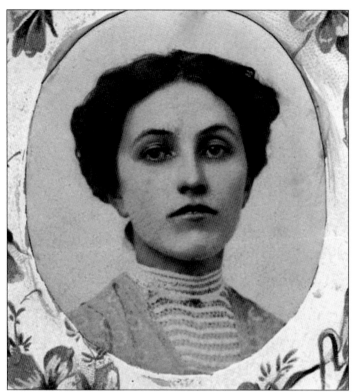

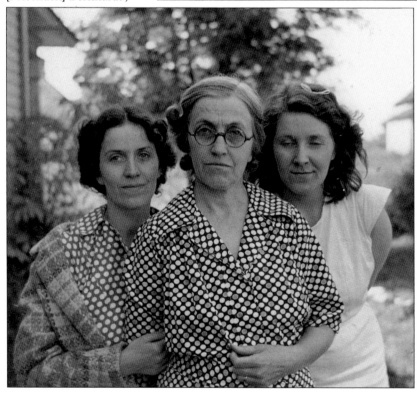

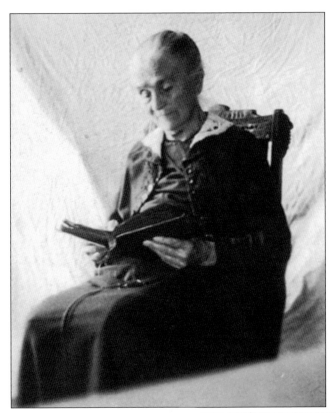

Eliza Clark (1851–1920) is pictured here toward the end of her life. Though she suffered the unbelievable pain of losing three young children and the countless difficulties of pioneer life, she remained a giving woman of deep faith and good cheer who was much beloved by the Kirkland community. (KHS and Patty [Fessenden] Bernhardt.)

Martin Clark (1849–1912) relaxes at home while enjoying his granddaughter Margaret Alice (Patty) Fessenden (1906–1996) in this c. 1906 image. His expression reveals the joy his grandchildren inspired after having suffered such loss and tragedy when Washington was still a frontier territory. A man of deep faith, Clark cofounded the First Baptist Church of Kirkland in 1890. (KHS and Patty [Fessenden] Bernhardt.)

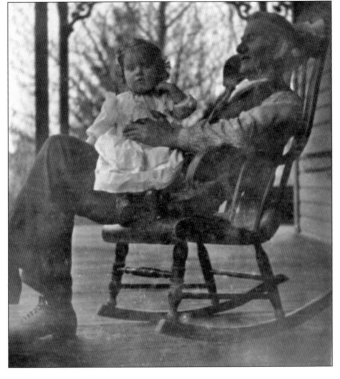

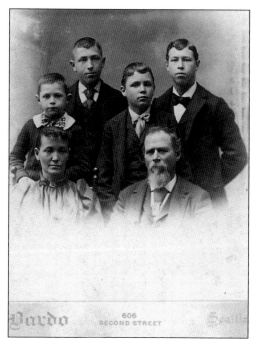

Juanita's pioneer Forbes family is seen here in the 1890s. Civil War veteran Dorr and Eliza brought their family west via train from Iowa to San Francisco. They made their way north, eventually coming to Juanita Bay in 1877. They lived initially in a log home at the corner of 116th Street and 100th Avenue, and Dorr staked a claim at Rose Hill, on the lake that bears their surname.

Seen here is the Forbes house, built in 1885. By the 1880s, the Forbes family had purchased a narrow waterfront strip of Martin Hubbard's land. Dorr dammed Juanita Creek to create a mill pond, where he operated a small shingle mill that eventually burned down, as did this home in 1905. They constructed a second home on the site that year, and it still stands today on the northern side of Juanita Beach Park. (Forbes Collection, KHS.)

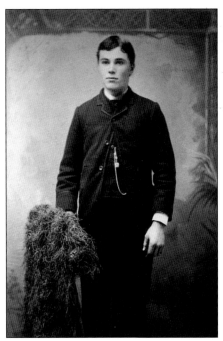

Harry Williams Langdon (1870–1927), pictured, was the adopted son of Juanita pioneers Rowland and Catherine Langdon, who came to Juanita in 1877 from Wisconsin. Part of their homestead comprises today's McAuliffe Park. Rowland logged in the area, and Harry grew up in that business. Despite an arm birth defect, he participated in logging much of Juanita and Finn Hill. He later opened a store and garage at Juanita Junction.

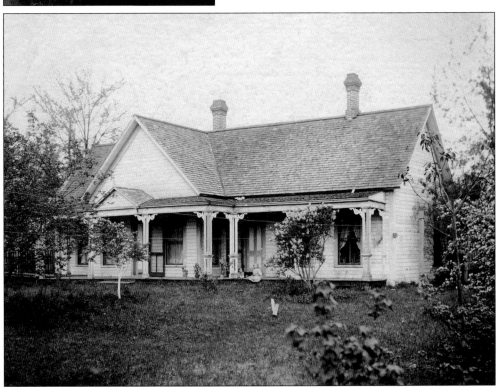

The Langdon home, built in 1884, is seen here in the 1900s. The Langdons sold it to Julius and Anna Ostberg in 1903 for $2,500, along with 25 acres. Though remodeled in the 1940s, thus removing many of its Victorian adornments, the house still stands today at McAuliffe Park, facing NE 116th Street. It is the oldest dwelling on a Kirkland park. (McAuliffe family.)

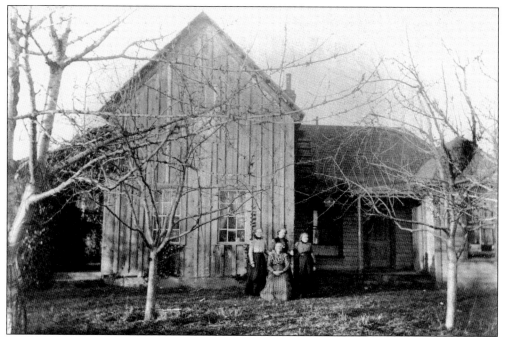

The Ole and Marit Josten home is pictured here. The Jostens came to Juanita in the 1880s, homesteading south of today's NE 132nd Street, where Juanita High School is today, and west to 100th Avenue NE. Marit is seated, with (from left to right) daughters Annie, Rosie, and Minnie standing behind her. Minnie, who suffered a disability from having had polio as a child, married Harry Langdon. In 2017, Josten Park was named in the family's honor. (Clair Kenney.)

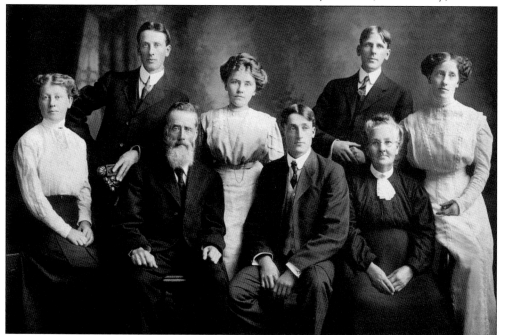

The Josten family is seen here around 1911. Ole and Marit are seated on either side of son Olaf. In the second row are, from left to right, Anna, Henry, Minnie, Sylvert, and Rose. (Clair Kenney.)

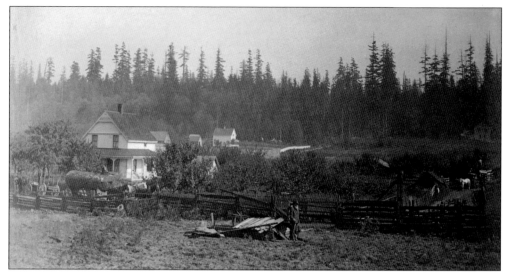

Norwegian immigrants Olaf (who went by "Ole") and Anna Ormbek settled on a 160-acre northeast Juanita homestead in 1883. Ole's ranch was located roughly south of today's NE 145th Street and east of Juanita-Woodinville Way NE. This c. 1900 view probably faces east, and Ole is in the foreground. Note the huge old-growth log on the wagon at left. (KHS and Tami [Ormbrek] Jones.)

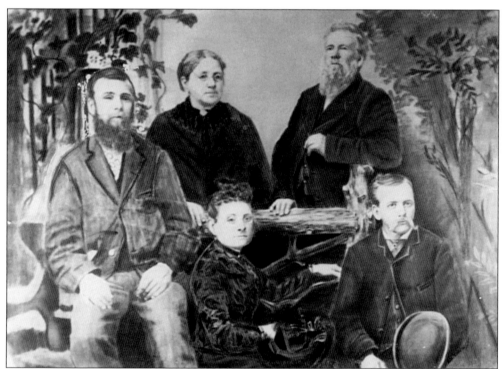

This is a pencil sketch of the Dunlap family. Son Charles (seated far left) and his wife, Mary, settled in Juanita, in 1877. It was on their property that Juanita's first school was built; it was a small log structure. They had four children. Charles was a Civil War veteran who enlisted in the 4th Iowa Cavalry at 17 in 1863. He died in 1886 after being struck by a falling tree branch.

Two

BOOMTOWN!

Peter Kirk (1840–1916) of Workington, England, was a steel manufacturer who sought to relocate to the United States. He planned to manufacture rails for railroad use and began looking for a site on the Pacific slope to locate his mill in 1886. After considering a number of other Washington Territory locations, *Seattle Post-Intelligencer* owner S.J. "Leigh" Hunt assembled a group of powerful investors and persuaded Kirk to choose Lake Washington's eastern shore.

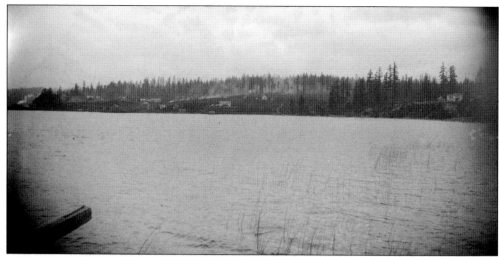

This view north across Moss Bay was captured in 1889. The smoke at far left is from a sawmill built over the lake. The two-story brick building is at the foot of Market Street, not yet cut. The Kirkland Land and Improvement Company crews are busy burning and cutting away the trees and brush of what will become the Norkirk neighborhood. Most of the large Douglas fir trees were toppled and simply lit on fire where they lay.

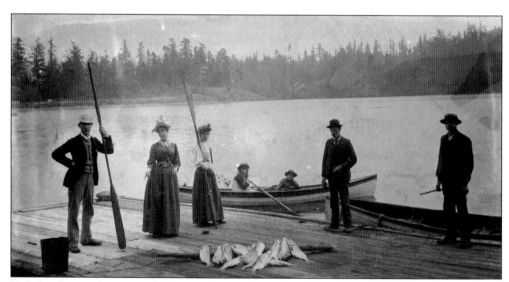

Kirk family members pose during a c. 1890 San Juan Island fishing trip. From left to right are Peter, Fanny, Margaret Hughes, Jessie and Peter Jr. in the boat, possibly Harry French or a visiting Kirk brother, and unidentified.

Mary Ann (Quirk) Kirk (1840–1907), Peter's wife, immigrated to the Washington Territory with the children in 1888.

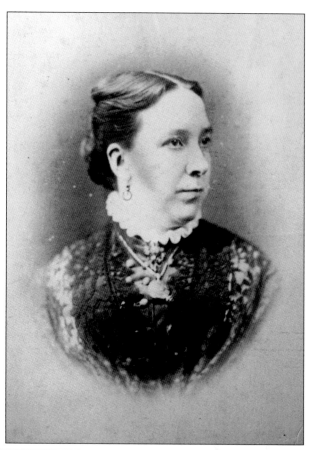

This is a rare photograph of Mary Ann Kirk with six of their eight children and the housekeeper, Margaret Hughes. Hughes traveled from England with them. From left to right are (first row) Jessie, Arnold, and Clara; (second row) Mary Ann; (third row) Olive, Margaret Hughes, Peter Jr., and Fanny.

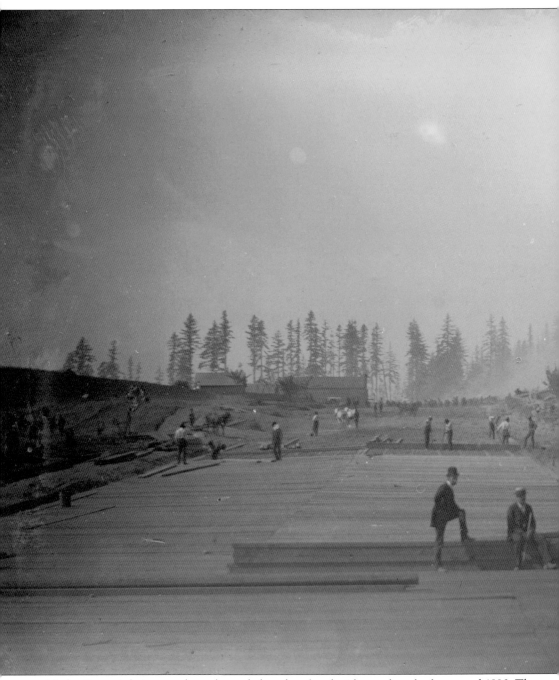

Market Street is being cut through, graded, and surfaced with wooden planks around 1890. The house and barn in the background and the orchard immediately east of Market Street had belonged to Andrew Nelson, the original homesteader who owned what is now the Market Neighborhood.

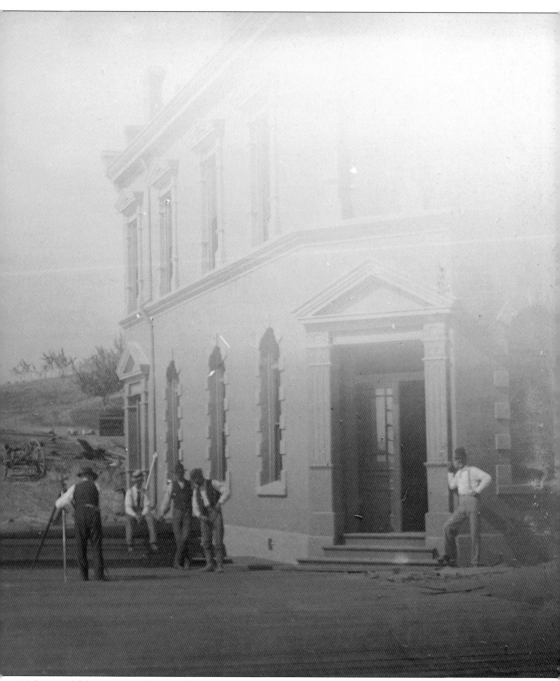

Nelson sold his entire claim to Kirk's associate S.J. "Leigh" Hunt, who transferred title to the Kirkland Land and Improvement Company. The brick structure at right served as the company offices; for decades, it was known by Kirklanders simply as the "Bank Building."

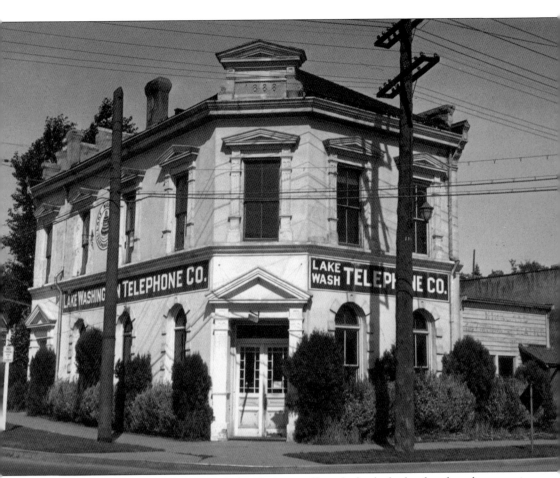

Built in 1888 at what became 210 Market Street as offices for both the land and steel companies, over the years, the Bank Building served as a bank, telephone company office, and the first meeting place for the Kirkland Town Council after Kirkland's incorporation as a fourth-class town in 1905. The building was demolished in the 1950s, and the site was used for parking for many years until it was redeveloped in the 2000s as a condominium.

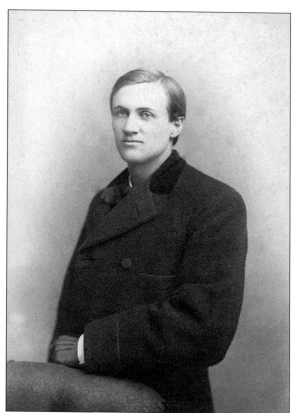

A promoter's promoter, described by a contemporary as "a man of very unusual talents," newspaper publisher and political boss Smith James "Leigh" Hunt originated the idea of a steel mill on Lake Washington and recruited Kirk to join him in the vision of an industrialized Eastside. Hunt built an impressive home he named Yarrow on the point that now bears that name. Hunt's Point was named for him too. He never lived there, but he purchased it just to cut the trees that blocked his western view from Yarrow. Of Lake Washington's east shore's potential as a mill site, he told Kirk, "The possibilities are endless." Though Kirkland bears Kirk's name, it was indisputably Leigh Hunt who "invented" it.

This was the view to the southeast at would soon become the foot of Market Street. The lake was nine feet higher then; the lake bottom beneath the steel mill company wharf is today part of Marina Park's parking lot. Andrew Nelson's homestead structures are seen at left. The photographer was positioned about where Heritage Hall stands today.

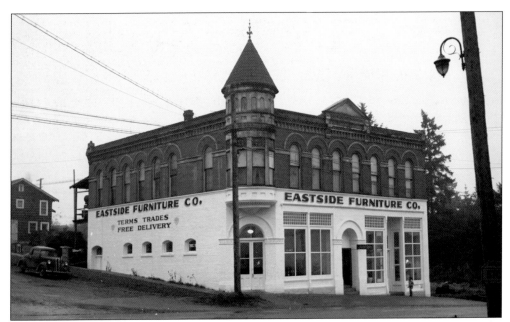

The iconic Peter Kirk Building at 620 Market Street was completed in 1892 at what was to be the heart of Kirkland's business district. Seventh Avenue, originally named Piccadilly Avenue, was to have been the primary thoroughfare linking the mill on Forbes Lake to the business area on Market Street.

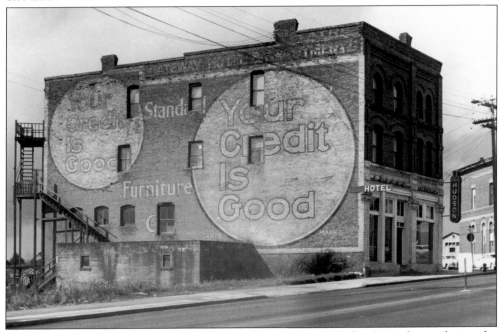

The building at the southwest corner of Seventh Avenue and Market Street began during the Kirk boom as a hotel called the Jackson, named for its original owner, Daniel B. Jackson, the grandfather of Dan Evans, the former US senator and governor. It served other uses over the years, including as Kirkland's first stage theater and its first movie theater; it later became the Leland Hudson dealership. It was demolished in 1964.

Newspapers actively promoted the Kirkland townsite with grandiose predictions of its future as a steel metropolis. The Filson & Timmerman store, advertised in the photograph below, was located in the original Peter Kirk Building on Seventh Avenue W. The Filson named was none other than C.C. Filson, who left Kirkland and created the outdoor clothing company of the same name in 1897.

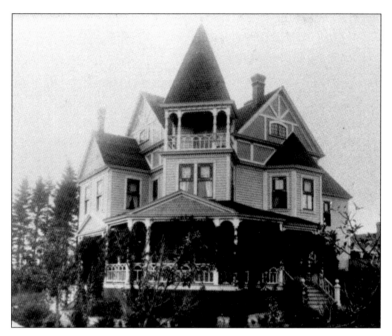

The Kirk family lived in a home they called Fir Grove. It stood on Waverly Way near Second Street W. The mill enterprise failed just prior to the Panic of 1893, and many of its backers were ruined. The Kirks still had money in England, but the Kirkland mill dream was dead. They moved to San Juan Island, but Kirk remained active in Kirkland affairs until his 1916 death.

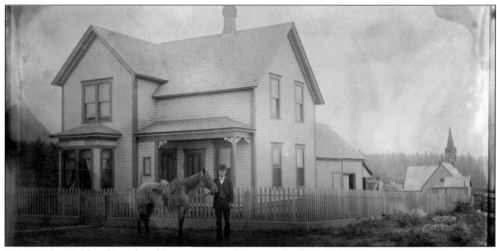

In 1889, the Kirkland Land and Improvement Company built eight homes. Seven were constructed west of Market Street for steel company executives, but one was built east of Market, at 127 Seventh Avenue, then named Piccadilly Avenue for Dr. William Buchanan, Kirkland's first physician (note the sign above the window). This may be Buchanan in this 1890 photograph. Behind the house is the Kirkland First Baptist Church. The home was later occupied by Dr. Barclay Trueblood and, for decades, was called simply the Trueblood House. In 2016, it was saved from demolition, and in 2017 was moved one block south.

Articles of Incorporation of The First Baptist Church of Kirkland (Wash.)

Know all men by these presents, That we, the persons hereinafter named, being desirous of forming a corporation for a church, do hereby adopt the articles following, certifying as follows, that is to say:

II

The names of us, the persons concerned, and who have associated together to form a body politic, are Benson L. Northup, Martin H. Clark, Mrs. Annie E. Houghton, Mrs. Eliza Clark, Rev. D. T. Richards and Mrs. Lucy L. Richards

III

The corporate name of the church is "The First Baptist Church of Kirkland" and its location and chief place of business are at Kirkland in King County, Washington.

The boom had tremendous impact on the homesteaders. Many sold land to speculators, and others invested their savings into development. New church buildings also sprung up on Seventh Avenue, and the Congregational church moved from Houghton to a new home at Fifth Avenue and First Street. The new Kirkland First Baptist Church was established next door in 1890; its founders included the pioneer Clark, DeMott, and Northup families, as seen in the church's hand-written 1890 articles of incorporation.

In testimony whereof we have hereunto set our hands this Seventh day of July A.D. 1890

Benson L. Northup
Martin H. Clark
Mrs. Annie E. Houghton
D. T. Richards
Mrs. L. L. Richards.

State of Washington } S.S.
County of King

This is to certify that the foregoing articles of incorporation were sworn to and subscribed by all and each of the persons whose signatures are thereto attached before me this Seventh day of July A.D. 1890

Jo. J. Beard
Notary Public
in and for the above named County and State residing at Kirkland therein.

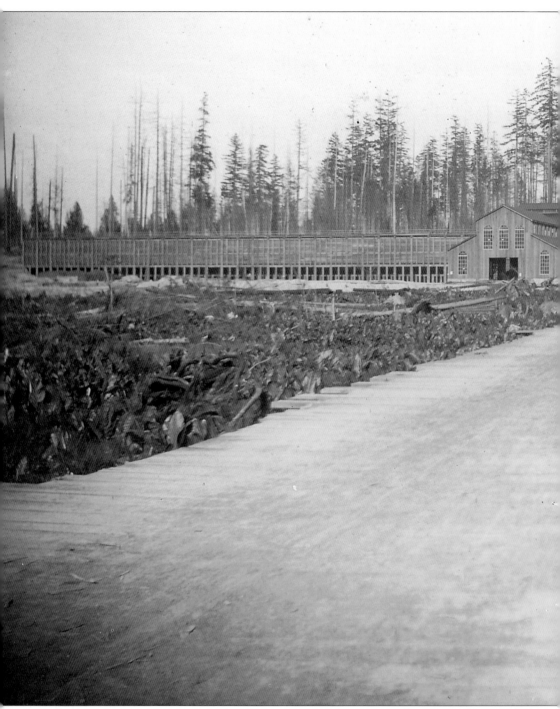

Kirk, Hunt, and their investors' steel mill was constructed on Rose Hill at the southeast end of Forbes Lake, near today's Costco store. This was the mill in 1890. The building in the foreground contained the pattern shop on the left, blacksmith shop in the center, and machine shop on the right. The structure behind at left is a raw materials storage bunker. At right is trestlework that was to facilitate rail supply of iron ore, coal, and lime. The mill was to manufacture steel rails for

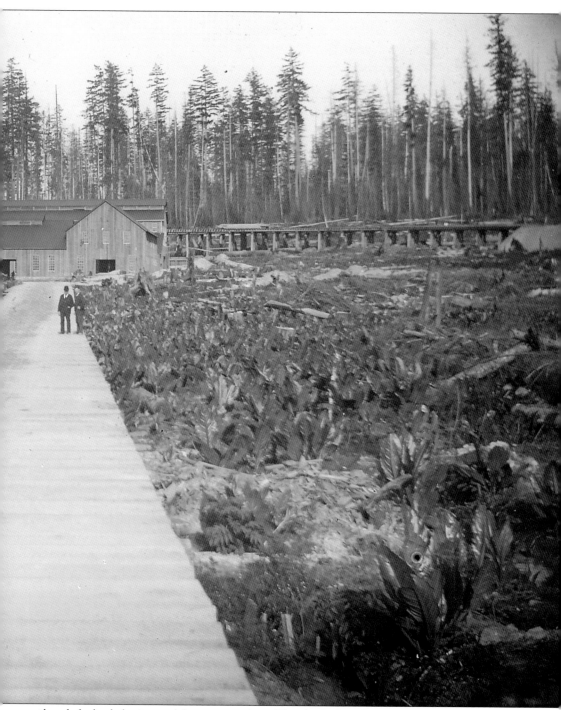

railroads for both foreign and domestic markets. The planked road, Piccadilly Avenue, much later renamed Seventh Avenue, ran from the mill all the way down to Market Street. From the skunk cabbage, it appears the photograph was taken in the spring of 1890. The two men are unidentified. Due to political and financial setbacks in 1892 and 1893, the mill never produced any steel.

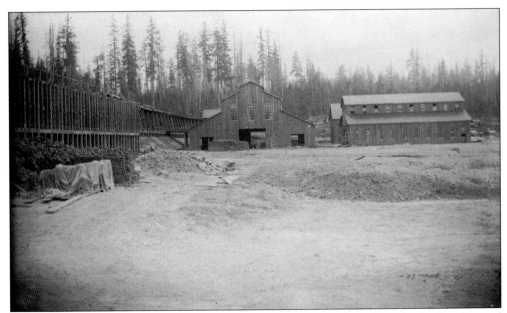

Pictured here from left to right are the bunker and its associated trestlework, the foundry, and the machine and pattern shops. Today's NE Eighty-Fifth Street would be about where the tree line is, behind the mill buildings. The bricks stacked near the bunker were made locally. There was a brickyard down in Kirkland and another about 1,100 feet west of the mill. Special firebricks intended for use in steel manufacturing were imported by ship from England. Detractors from rival towns like Tacoma derisively referred to the venture as "Kirk's Folly."

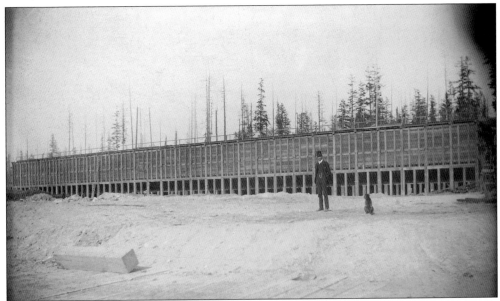

This is a closer look at the 350-foot long raw materials bunker, which was oriented north-south. Rails ran along the top, and ore cars were to dump into the structure below. At the tipple-like bottom, smaller cars would have been used to transport the ore, coal, and lime into the foundry and blast furnaces. The man is unidentified.

Three

AFTER THE BUST

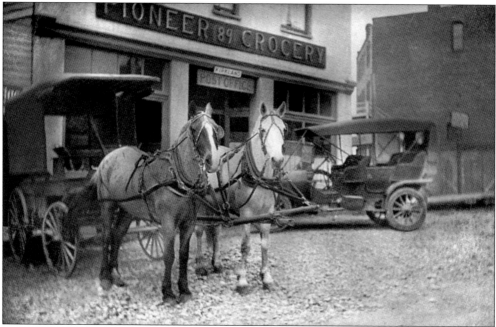

Grocer Emory Brooks came with his family during the Kirk boom, opening his first store around 1890 on Rose Hill, near the mill. The family stayed on during the tough years following the 1893 depression, and after having operated in several of the brick buildings at Seventh Avenue and Market Street, they built their own, the Brooks Building, which still stands at 611 Market Street. The Hotel Jackson is at right.

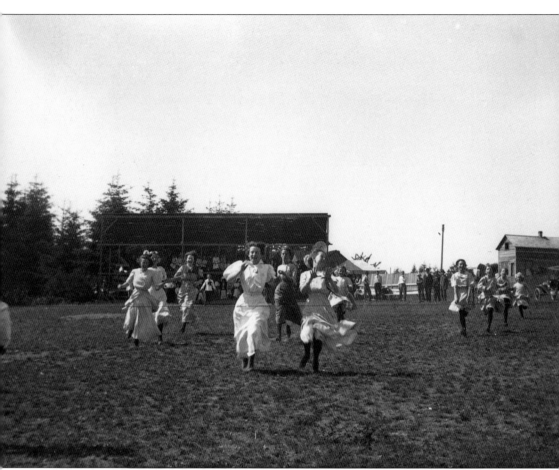

With political impediments to building a Lake Washington canal to Puget Sound and the depression of 1893, Kirkland's mill scheme imploded. Those who remained dug in and got to the hard work of building a town. It incorporated in 1905; however, it was not all hard work, as this c. 1895 image reveals. The girls are clearly having fun at the site of today's Heritage Park. Waverly Way is in the background. (KHS and the Marsh family.)

Sarah Francis Annabelle "Belle" Patty and Emory Brooks married in 1888 and relocated to boomtown Kirkland in 1890.

This c. 1900s shot taken in front of the Brooks Pioneer grocery reveals a dirt Market Street, wooden sidewalks, and the Peter Kirk and Campbell Buildings. The Campbell Building was constructed during the boom as an investment by pioneers Harry French and Ed Church. Like other pioneers, they suffered tough financial reversals when the mill failed.

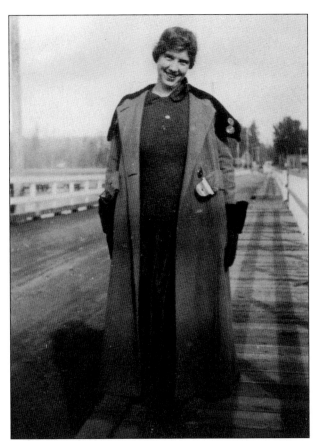

Brooks daughter Nora (Brooks) Boarts stands on the Juanita Bridge on October 12, 1918. The camera faces north. She was a young widow; her husband, Percy Boarts, at 22 years old and a private in the US Army, had died of bronchopneumonia eight months earlier while at aviation training camp in Texas.

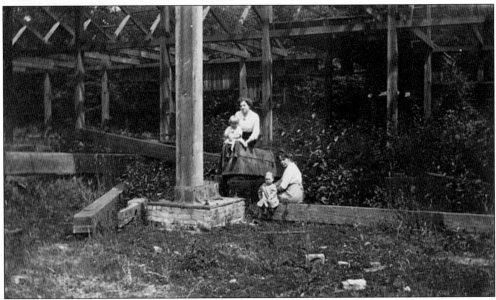

Members of the Lee family are seen here in 1914 in the ruins of the raw materials bunker at the former Great Western Iron and Steel Company's mill. The company assets had been auctioned off in a sheriff's sale years earlier. (Ryseff Collection, KHS.)

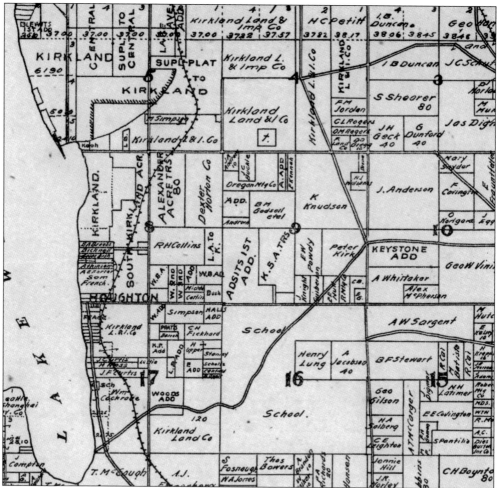

This map from the Anderson Map Company's *1907 King County Atlas* shows many of the town of Kirkland's property lines and parcel owners' names.

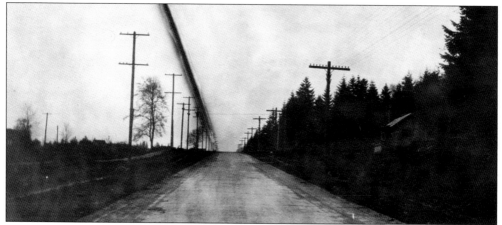

This is a c. 1905 view looking north up Market Street. This was likely headed out of town, perhaps from about 10th Avenue. (KCA.)

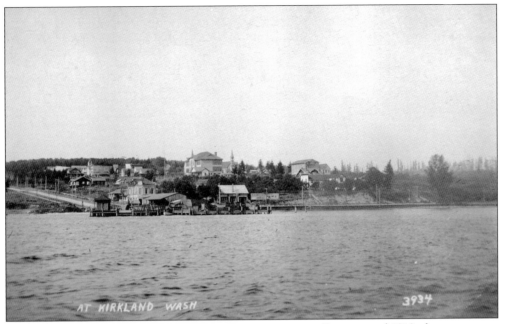

AT KIRKLAND WASH 3934

Seen around 1910, the structure at right on the hill is Elmer Gilbert's hotel, and the building on Central Way with three large doors is a blacksmith shop he co-owned with his son-in-law Carl Knauf. Elmer and Jennie Gilbert came to Kirkland during the Kirk boom but stayed on. They owned land from their hotel over to Market Street and a small home on Market Street behind the 1888 brick Bank Building.

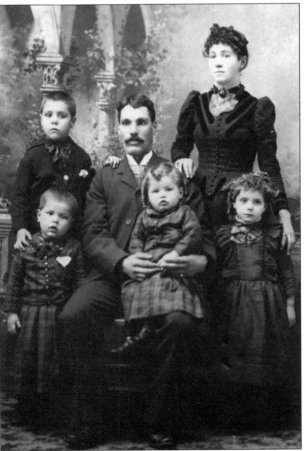

The Gilbert family is seen here around 1892. From left to right are (first row) Frank, Ernest Ray and Tressie; (second row) Charles, Elmer, and Jennie.

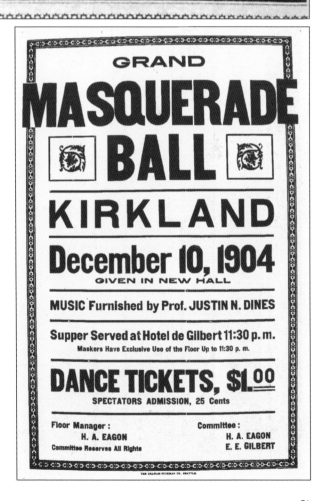

Elmer and Jennie's great-granddaughter Anita Maxwell provided these samples of early Gilbert Hotel advertisements. Economic times in Kirkland were quite tough in the 1900s and early 1910s, but Elmer had success in several business ventures and in real estate.

Peter Kirk et al.
to Warranty Deed.
Almer E. Gilbert.

This Indenture, made this 19th day of June in the year of our Lord one thousand nine hundred and two (1902)

Between Peter Kirk & Mary A Kirk and H H Meeker & Jane E Meeker his wife the parties of the first part and Almer E Gilbert party of the second part;

Witnesseth, That the said parties of the first part for and in consideration of the sum of One hundred Dollars of the United States, to be in hand paid by the party of the second part, the receipt whereof is hereby acknowledged, do by these presents Grant, Bargain, Sell, Convey and Confirm unto the said party of the second part, and to his heirs and assigns, the following described tract lots, or parcel of land, lying and being in the County of King, State of Washington and particularly bounded and described as follows, to wit:

This early deed conveys land in Kirkland previously owned by Peter and Mary Kirk to Elmer and Jennie Gilbert.

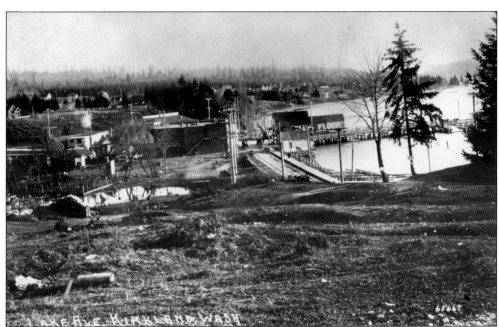

This was the view to the south from the Gilbert Hotel, looking down Lake Street. With the lake nine feet higher, it is easy to see how the street got that name, since the shore came right up to it. The businesses on the west side of the street were constricted over the lake on pilings. Much of the area around today's Park Lane was then a swamp where a creek spilled into the lake. The creek still exists but now runs through a culvert beneath the asphalt to the lake.

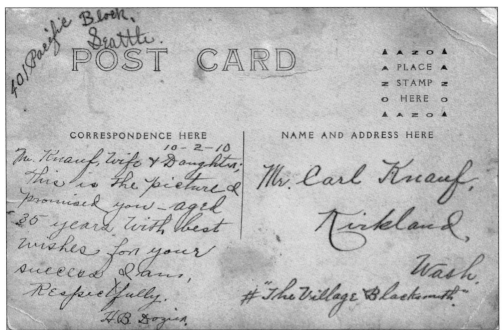

10 - 2 -10

Mr. Knauf, Wife & Daughters; this is the picture I promised you - aged 35 years, with best wishes for your success I am, Respectfully. H.B. Dozier.

Mr. Carl Knauf, Kirkland, Wash. #"The Village Blacksmith"

Carl Knauf married Tressie Gilbert in 1908 and Elmer brought him into the blacksmith business he owned. He was well remembered for his knack for fabricating and repairing metal items for Kirklanders. The Knaufs' home was demolished but stood on the southwestern corner of today's Kirkland City Hall property, land once owned by the Gilberts. Knauf was also an inventor; in the 1920s, he patented and manufactured a lawn mower–sharpening device. (Both, Anita Maxwell.)

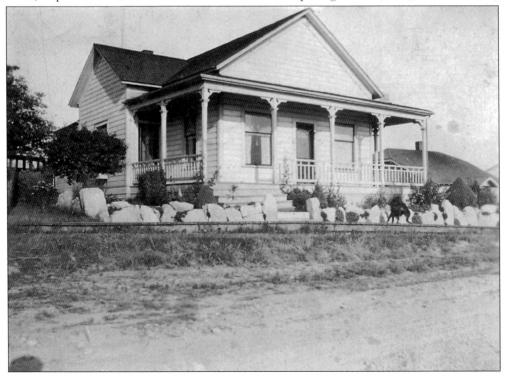

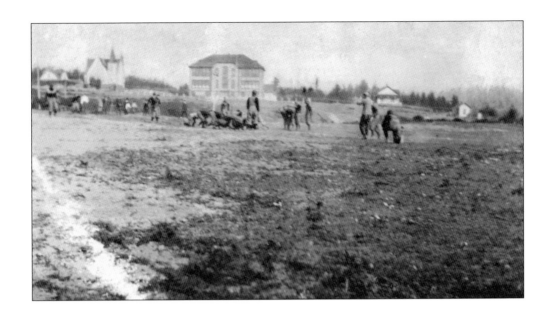

These c. 1914 images of a Kirkland High School football game are from the photo album of Harry French's daughter Olivia (French) Davis (1896–1945). Looking east, the large structure in the background is the Central School, built in 1904. At far left is the Kirkland Congregational Church, built around 1890, and at far right is the Knauf home. The boys are playing on the field that is today's Heritage Park.

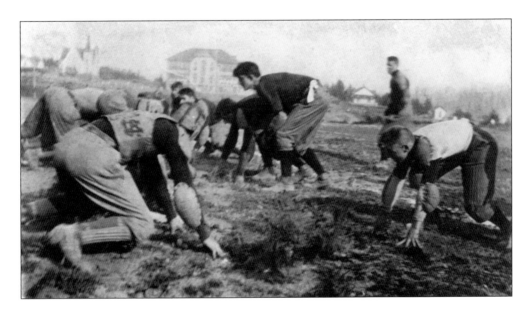

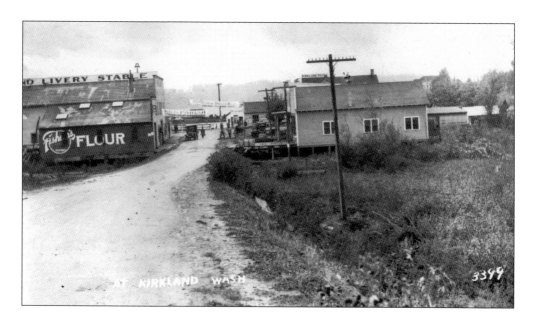

These are two views west down Kirkland Avenue in 1912 (above) and c. 1915 (below). Above, political banners are stretched across the street. By 1915, a wooden sidewalk has been added and behind the J.G. Robinson Mechanic building (owned by James "Jimmy" Gardiner Robinson, who was likely Kirkland's first Ford dealer), the stacks of the ferry *Lincoln* are visible behind the fire bell.

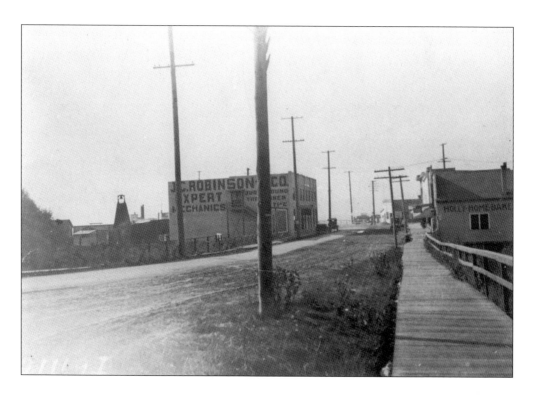

This view north up Lake Street is from around the early 1920s. The building at right burned in the early 1970s. The smaller building beyond was a Ford dealership. The Central School on the hill above stands on the site now occupied by Kirkland City Hall.

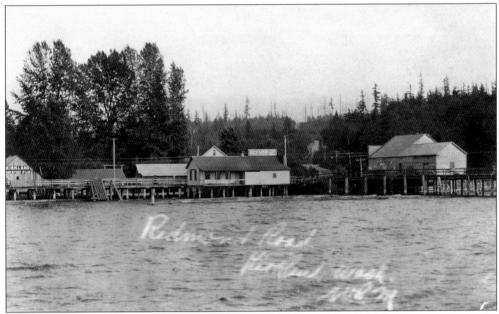

This c. 1905 view looks east on Lake Street. The King County ferry dock is at the right at the foot of Kirkland Avenue, which is seen leading up the hillside. It was then the only route from the ferry to Redmond.

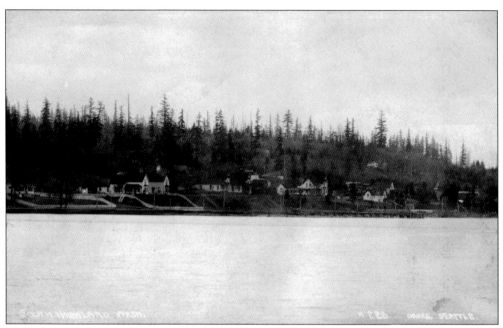

This photograph is of what was then called South Kirkland from around 1910. This image was captured near today's Seventh Avenue South.

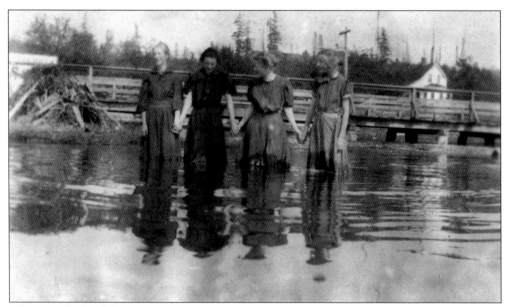

Fifty years before bikinis graced the Houghton waterfront, this c. 1914 image from the Olivia (French) Davis album captured four of her friends—from left to right, Antoinette Shumway, Hattie May Chapman, Juanita Parker and Ruth Shumway—wading in their "wash dresses." The French house is at right, and the road on pilings behind the girls is today's Lake Washington Boulevard.

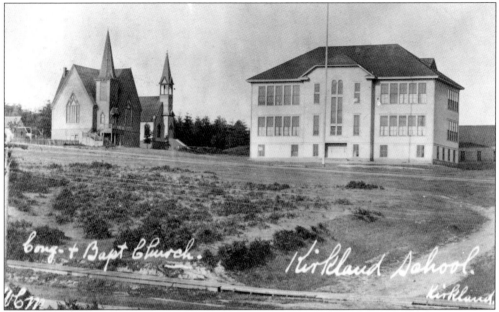

From left to right, the Kirkland Congregational Church, the Kirkland First Baptist Church, and the Central School are seen about 1910. The school stood on the site of today's Kirkland City Hall at 123 Fifth Avenue, and was replaced in the 1930s. The new building was also called the Central School and was demolished in the early 1980s for city hall construction.

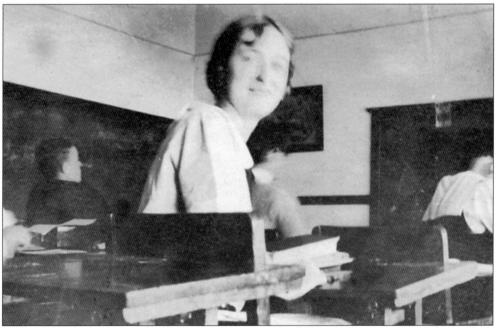

This is a rare image from inside the Central School of Alice (Ostberg) Johnson in around 1924. After graduating, while still in her late teens, she became an elementary school teacher, commuting via dirt and gravel roads to Phantom Lake Elementary School in what is now the city of Bellevue, though at the time Phantom Lake was just a tiny, unincorporated farming community. (McAuliffe family.)

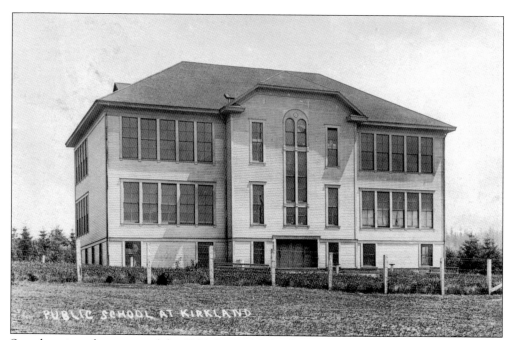

Seen here is a closer view of the 1904 Central School. It was constructed by prolific Kirkland builder J.G. Bartsch, who also built the Shumway Mansion and a host of other buildings and homes from that era. It was razed in 1935 and replaced with another Central School. In 1982, the current Kirkland City Hall was built on the site.

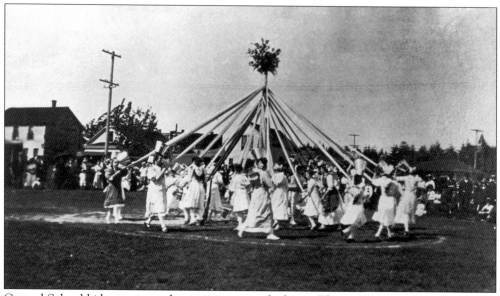

Central School kids are pictured enjoying a maypole dance. This c. 1914 view faces north from the site of today's Heritage Park.

The King County road crew paves the Kirkland-Houghton Road in the c. 1910 image above. The photograph below faces north up the Kirkland-Houghton Road (today's Lake Washington Boulevard), from just south of today's Carillon Point. (Both, KCA.)

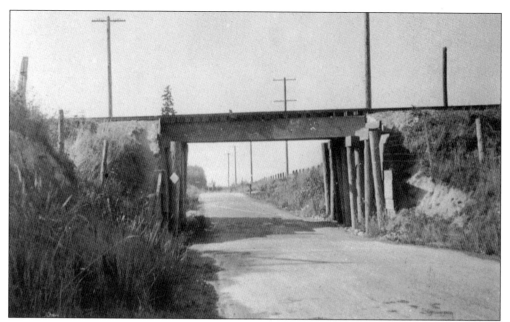

When the Northern Pacific Railroad completed its Lake Washington Belt Line in 1904, it was outside the Kirkland town limits. The line was constructed for freight transport, especially agricultural goods, not passenger service. This shot looks east at what the Northern Pacific Railroad designated Bridge 16, which today crosses NE Sixty-Eighth Street in Houghton. It was taken around 1905, shortly after the belt line opened. (KCA.)

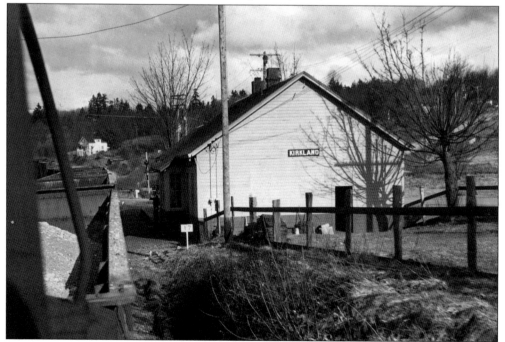

Kirkland did have a small freight depot; it was constructed in 1912 and stood on Railroad Avenue near Kirkland Way and Kirkland Avenue. The station was replaced with a much smaller one in 1973, and that was later removed, though its concrete pad remains at the site. (NPRHA.)

The 1912 Kirkland Depot is seen here looking north from Railroad Avenue in the 1950s. The area immediately south of the depot, named Feriton by the Northern Pacific Railway, contained several industrial businesses with rail spurs from the decades after the Lake Washington Belt Line opened in 1904. Kirklanders called the Feriton area "the railroad yard." (NPRHA.)

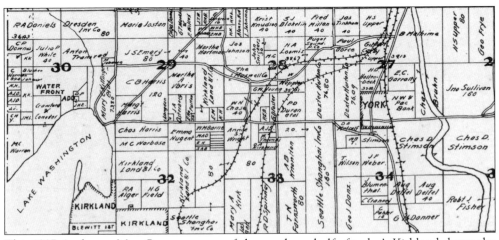

This 1907 Anderson Map Company map of the northern half of today's Kirkland shows the landowners by name and also shows the Northern Pacific Railroad's Lake Washington Belt Line, built in 1904, and the route of the earlier Seattle, Lake Shore and Eastern Railway (SLS&E) spur to the steel mill. The SLS&E line is to the right (east); much of its rail bed later became Slater Avenue.

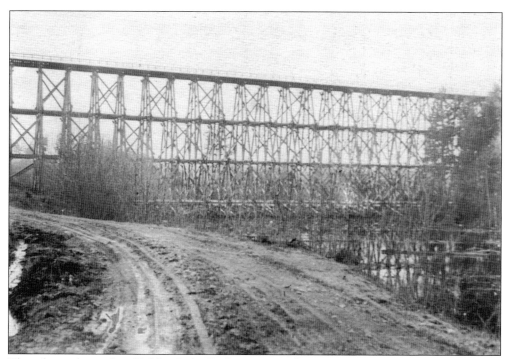

Though not located in Kirkland, the Wilburton Trestle is unquestionably the most dramatic point along the former Lake Washington Belt Line. It is seen here around 1905 shortly after its completion. Richards Road runs beneath the trestle, and the water at right is Mercer Slough, then much deeper because the lake was nine feet higher. Shallow-draft steamboats were then able to navigate from the lake all the way up to Wilburton. (KCA.)

South Kirkland resident Louis "Louie" Marsh (known as "2E" by close friends and family, thanks to his younger brother Phil's repeated childhood mispronunciation of "Louie") was a highly talented metallurgist and engineer who was one of the first people hired by the Boeing Airplane Company. Highly successful early in his career, he built the spectacular Marsh Mansion, which still stands on its original location on Lake Washington Boulevard.

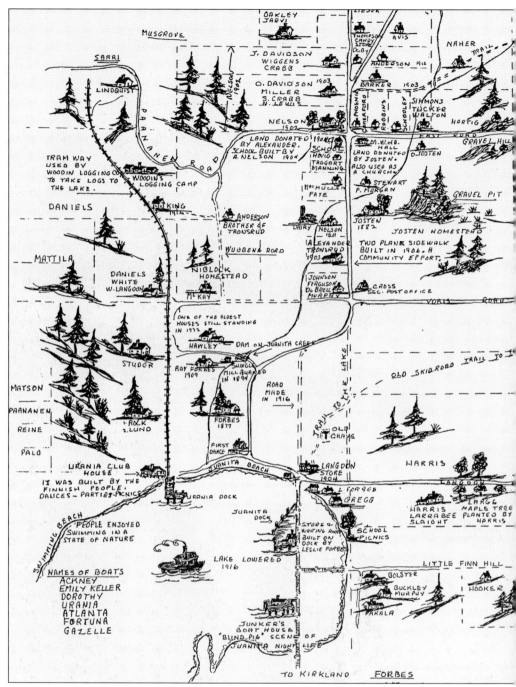

Ruth Nelson grew up in the 1900s and 1910s on her family's property at the northwest corner of NE 132nd Street and 100th Avenue NE. In the early 1970s, she hand drew this *Juanita: Remember When* map, which provides details and recollections about her early neighbors. It reveals fascinating long-forgotten details, such as a logging skid road stretching between the Johnson property near

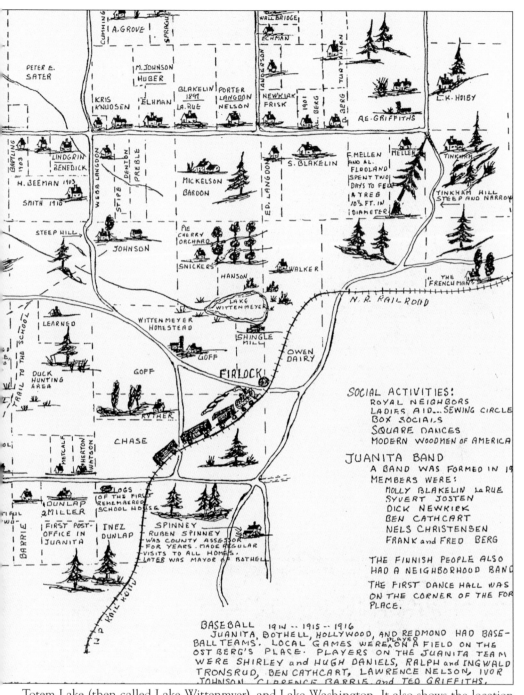

Totem Lake (then called Lake Wittenmyer), and Lake Washington. It also shows the location of a logging tramway from Finn Hill to the lake, near the western edge of Juanita Beach Park. (King County Library System.)

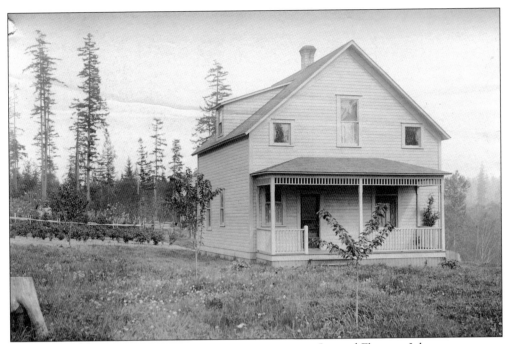

Joe and Florence Johnson were Swedish immigrants who owned property that straddled today's Evergreen Hill (also known as Kingsgate) and Totem Lake neighborhoods. Above is their second house there, built in 1904. The Johnsons' land included a portion of the northwestern Totem Lake Mall parking lot and Interstate 405. Their house was located between Totem Lake Mall Boulevard and Interstate 405, just south of NE 128th Street. Like many early Juanita residents, Joe and their five sons were involved in logging at various times. Joe is seen at left. (Both, McAuliffe family.)

Florence Johnson is seen at right. Below, several of her and Joe's sons are out in the woods working with the Siler Logging Company, a major Eastside operation based in Redmond. The crew has just felled a massive first growth Douglas fir. The image reveals some of the iconic tools of the logging trade during the late 19th and early 20th centuries: a two-man crosscut felling saw, known as a "misery whip," and double-bitted felling axes. The crews would first chop a large notch, called an "undercut," using axes, and then saw from the opposite side, creating the "backcut." During the backcut, the tree would collapse under its weight into the undercut to the ground. The bottle with a hook attached hanging from the stump contained oil used to lubricate the saws. (Both, McAuliffe family.)

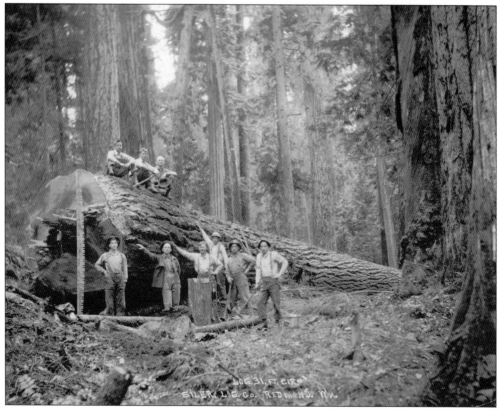

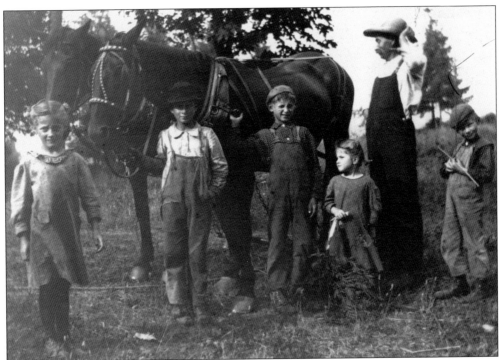

Marten and Maren Mickelson emigrated from Norway in the 1880s and owned a large parcel of land in today's Evergreen Hill Neighborhood, south of NE 132nd Street near today's Evergreen Hospital campus. The image above is of Marten with a team of horses he used for farmwork, and some of his six children. The photograph below looks west on today's NE 132nd Street and was taken from the Mickelson property. The Mickelson family's first residence was a log cabin, but they later constructed a frame house. Mickleson Pond was near their home, and it still exists today, surrounded by office and medical buildings, just southeast of the intersection of NE 132nd Street and 120th Avenue NE.

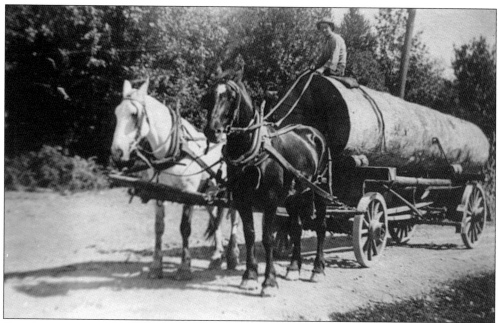

Seen here are two different images of Harry Langdon (1870–1927), whose earliest vocation was in the logging business, where he was a teamster. As a boy in the 1880s and 1890s, Harry worked alongside his father, Rowland, and brothers cutting trees on their own land at the site of today's McAuliffe Park on Little Finn Hill and on neighbors' property and in and around Juanita and Big Finn Hill. Harry was adept at driving yokes of oxen and teams of horses to remove old growth giants despite a birth defect that gave him limited use of one of his arms. By the 1900s, the internal combustion engine was revolutionizing logging and Harry quickly mastered early log trucks. He also opened one of the area's service station/garages in 1917 at the Juanita Junction—the intersection of NE 116th Street and 100th Avenue NE.

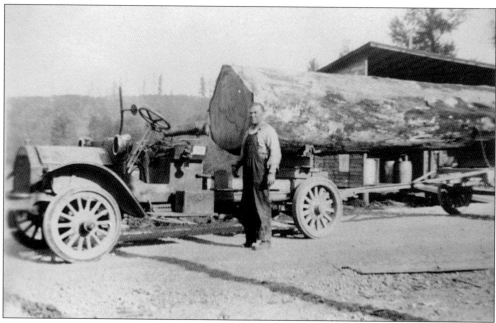

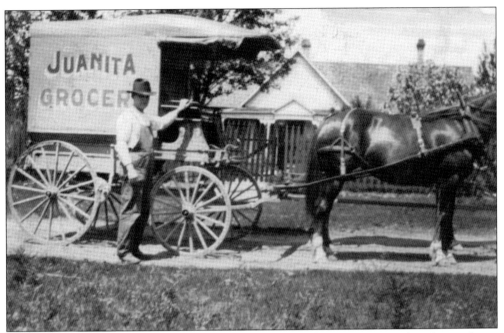

Harry Langdon had also entered the grocery business in 1902; his store stood at the northeast corner of Juanita Junction. He married Juanita pioneer daughter Minnie Josten in 1907. Harry was known as a kind-hearted "soft touch" in his role as grocery store owner; as economic times grew tough by the late 1920s, he often extended credit to families who could not or simply did not repay their grocery bills.

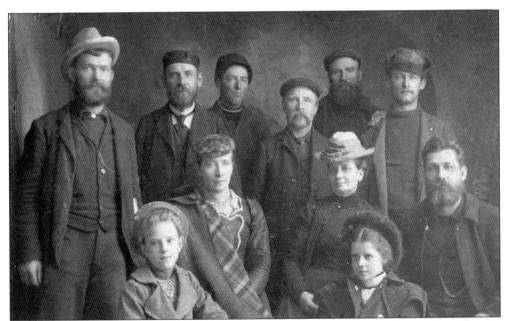

Anna (Larson) Ostberg (1875–1949) immigrated from Sweden in 1890. After reaching Seattle, she ventured north to work in an orphanage in Alaska. She is seen here around 1900 (center row, seated left) with a group of fellow Alaska-bound Swedes. (McAuliffe family.)

Julius Ostberg (1874–1910) was the son of Swedish immigrants who was born in Kansas. He and Anna Larson married in December 1903. Soon thereafter, the young couple purchased the aging Rowland and Catherine homestead, which included the frame home and 25 acres, for $2,500. The Ostbergs soon added a barn, which remains on the McAuliffe Park property. In the photograph below, facing east, Anna and Julius Ostberg are seen in the 1900s on NE 116th Street, which was then called Langdon Road. Given their attire, it is likely they were walking home from the Juanita steamer landing after a trip into Seattle. The Ostbergs named their youngest daughter Urania after the primary steamboat that served Juanita Bay. They had two other children: Alice and David. (Both, McAuliffe family.)

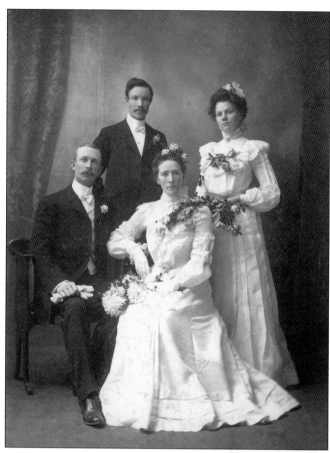

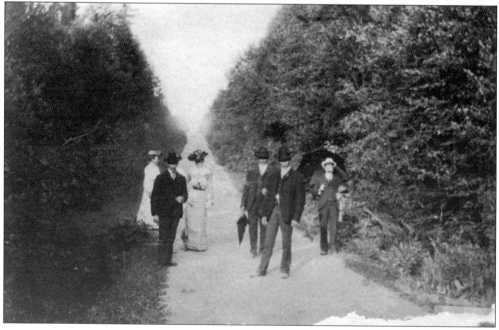

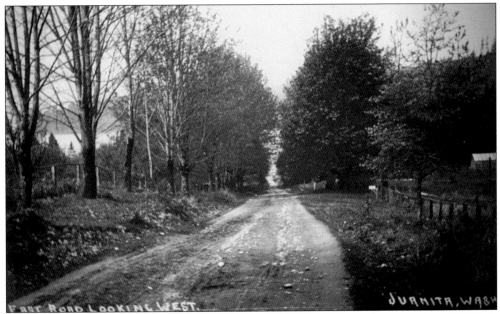

This 1900s Juanita postcard is labeled East Road, which would make it a view west down NE 112th Street toward Juanita Bay. However, some Kirkland history researchers believe it is mislabeled and is actually Langdon Road, today's NE 116th Street. If it is NE 112th Street, the residents were primarily Finnish immigrants or of that ancestry, thus the origin of "Little Fin Hill," though that term has lost popularity.

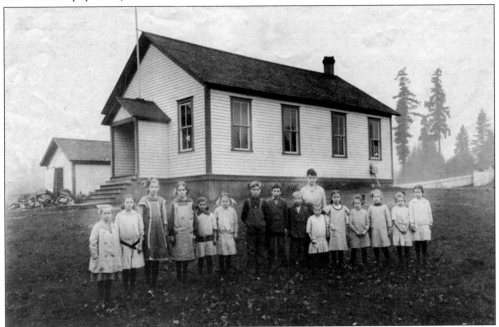

The very first Juanita schoolhouse was a crude log structure dating from around the 1880s located on the Dunlap property, south of NE 116th Street a few blocks west of Interstate 405. It was replaced by this frame structure in the early 1890s. It stood north of NE 116th Street at about 112th Avenue NE. This image dates to the 1910s.

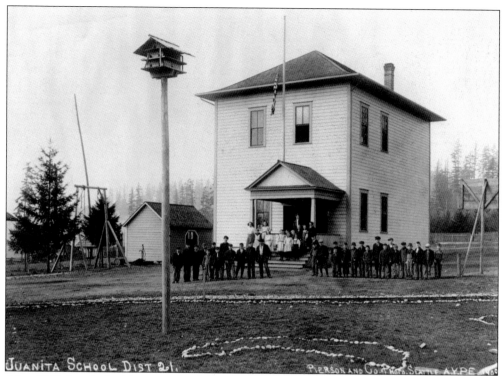

After 1884, Juanita had its own school district, District 21. The third Juanita School was located on the site of today's Juanita Elementary, at the southwest corner of 100th Avenue NE and NE 132nd Street. This photograph was taken in 1909 during the Alaska Yukon Pacific Exposition, and the school is seen in its original configuration. The view faces southwest toward Big Finn Hill.

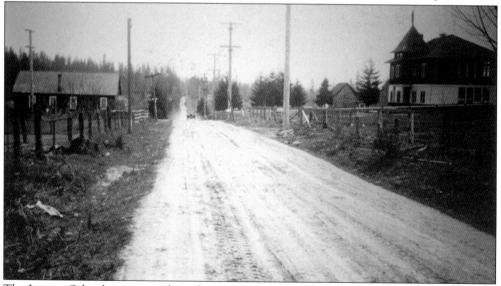

The Juanita School is seen on the right in this view looking south down today's 100th Avenue NE in the 1910s. By this time, the school had been enlarged substantially. The cross street at the intersection is NE 132nd Street. The building across 100th Avenue NE belonged to the Modern Woodmen of America, a fraternal organization.

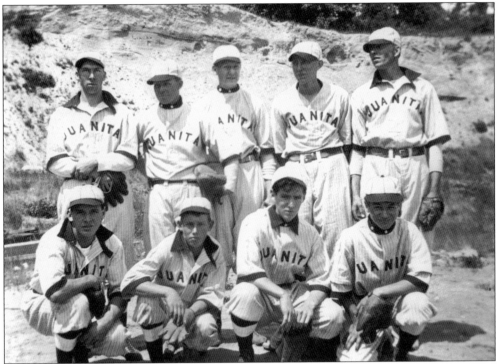

Baseball was enormously popular in Kirkland and the surrounding communities. Even Juanita had its own team, as seen here in 1918. Games were often played on the Ostberg property; Kirkland had its own field at the site of today's Heritage Park.

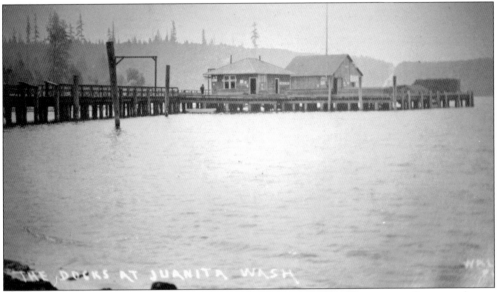

King County's Juanita Steamer Wharf is seen here around 1910. The camera faces southeast, and on the wharf is a small waiting area and another building containing a combination small confectionary store and storage area. The store was originally run by Harry Langdon, followed by Allen Forbes, and later by his younger brother Les and his wife, Alicia. The original c. 1890 Juanita Trestle is at left; the wharf extended out from that.

This Higginbotham family came to Juanita in the early 1900s. Their home was located directly north of the western portion of Juanita Beach Park. Here, several of the Higginbotham girls pose on the Juanita Bridge around the 1910s. (The Higginbotham family and Vicki Elwell.)

Much of Finn Hill in the early days was claimed by timber interests. Once cut, many parcels became available for purchase. A settlement of Finnish immigrants took hold by the 1900s. It was inaccessible except by boat, as Juanita Drive was not built until the 1920s and the first road to the settlement, NE 132nd Street, was not built until 1905. Here, members of the Reine family pose wearing distinctive Finnish attire.

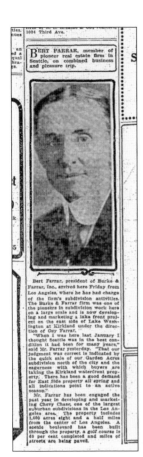

In 1910, Edmund Burke (below) and Bert Farrar's already successful real estate firm, Burke & Farrar, purchased the real estate assets of the old Kirkland Land & Improvement Company. With that, they owned most of the Kirkland townsite and much in the surrounding area. The two were visionaries; they saw Kirkland as a desirable Seattle suburb, where commuters were only a boat ride from the city or where families could live on multi-acre "stump ranches," engaged in berry cultivation, poultry raising, or similar agricultural pursuits. Burke died in a 1915 auto accident, but his family retained ownership of Kirkland for many decades. Farrar moved to Los Angeles in late 1923 or early 1924, but his brother Guy, of Kirkland, continued to handle Burke & Farrar business interests. (Left, *The Seattle Times*; below, Deb Healey.)

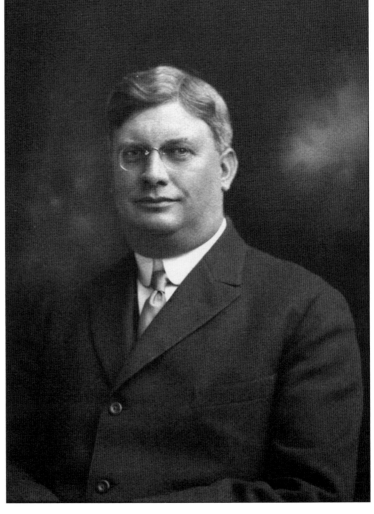

Burke & Farrar were great believers in advertising and generated prolific ad copy promoting Kirkland. Their ads captured readers' imaginations and painted a detailed picture of the life one could expect in Kirkland. They often boldly and dramatically challenged the reader in a way that was uncommon among rival area real estate promoters. The Burke & Farrar company had sales offices in downtown Seattle at the King County ferry docks at Madison Park and Kirkland Avenue and in several other Kirkland locations over the years, including the building they constructed in 1918 at the northwest corner of Lake Street and Kirkland Avenue, which still stands today. (Both, *The Seattle Times.*)

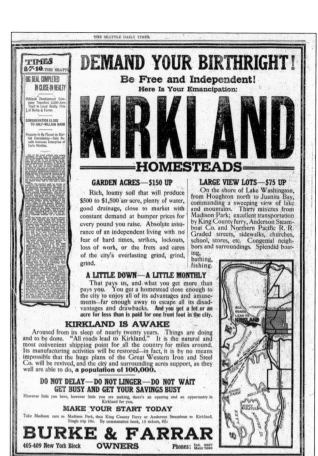

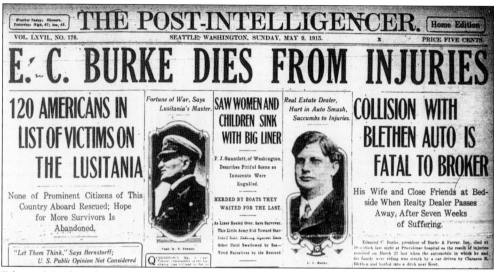

THE POST-INTELLIGENCER. Home Edition

VOL. LXVII., NO. 176. SEATTLE, WASHINGTON, SUNDAY, MAY 9, 1915. x PRICE FIVE CENTS.

E. C. BURKE DIES FROM INJURIES

120 AMERICANS IN LIST OF VICTIMS ON THE LUSITANIA

None of Prominent Citizens of This Country Aboard Rescued; Hope for More Survivors Is Abandoned.

"Let Them Think," Says Bernstorff; U. S. Public Opinion Not Considered

SAW WOMEN AND CHILDREN SINK WITH BIG LINER

Fortune of War, Says Lusitania's Master.

F. J. Gauntlett, of Washington, Describes Pitiful Scene as Innocents Were Engulfed.

HERDED BY BOATS THEY WAITED FOR THE LAST.

As Liner Heeled Over, Says Survivor, This Little Army Slid Toward Starboard Rail, Battling Against Each Other Until Swallowed by Sea—Vivid Narratives by the Rescued.

COLLISION WITH BLETHEN AUTO IS FATAL TO BROKER

Real Estate Dealer, Hurt in Auto Smash, Succumbs to Injuries.

His Wife and Close Friends at Bedside When Realty Dealer Passes Away, After Seven Weeks of Suffering.

Edmund C. Burke, president of Burke & Farrar, Inc., died at 10 o'clock last night at Providence hospital as the result of injuries received on March 21 last when the automobile in which he and his family were riding was struck by a car driven by Clarence B. Blethen and hurled into a ditch near Kent.

Edmund Burke's death in 1915 was front-page news in Seattle. The *Seattle Post-Intelligencer* reported his passing with a headline above news of the sinking of the *Lusitania*. In many respects, Edmund Burke & Bert Farrar shaped Kirkland's future as a suburban city in a manner unequaled by the earlier steel mill efforts undertaken by Peter Kirk and its other investors now recognized as Kirkland's "founders."

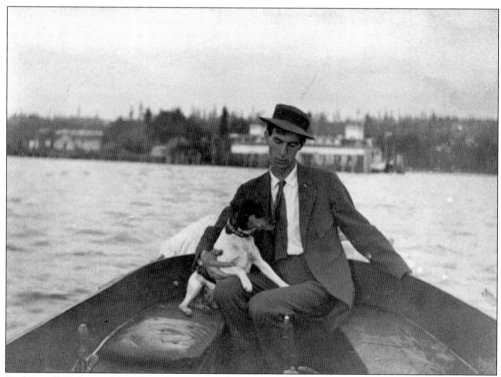

Earl Excell Etzler and his dog relax in a rowboat just offshore of the woolen mill. Behind him is the box factory (left), constructed during the 1890s; Heritage Park would today be to the right of Etzler. This image was captured around 1916 while the United States was still at peace; a bloody, near-stalemated struggle was unfolding in the muddy trenches of France. (Jan [Etzler] Strode.)

Earl Etzler was one of the first young men of Kirkland to answer Uncle Sam's call to fight the Germans in World War I. He managed to survive the horrifying new battlefield technologies, from machine guns and airplanes to poison gas. After the war, he returned to Kirkland with his new war bride, a beautiful French girl named Jeanne. They started a family soon after getting settled, and Earl Etzler Jr. was born in 1919. They later had two more boys, Henri (French spelling, courtesy of Jeanne) and Frances. Earl and Jeanne both rest in the Kirkland Cemetery. (Both, Jan [Etzler] Strode.)

EARL ETZLER SEES ACTIVE WAR SERVICE IN FRANCE

Letters from Earl Etzler, a popular East Side young man, announce his presence on the battle front in France.

Mr. Etzler joined the cavalry and was one of the first of the boys from this section to reach France. He has been detailed on mounted police work for some time and, if not transferred, is directing traffic on the arterial highways leading to the trenches.

It is said that the traffic on those roads is greater than on Broadway in New York, hence Etzler must have

EARL ETZLER.

quite a job. The danger question is another element in his work. The Germans, it seems, take special delight in shelling the highways behind the line.

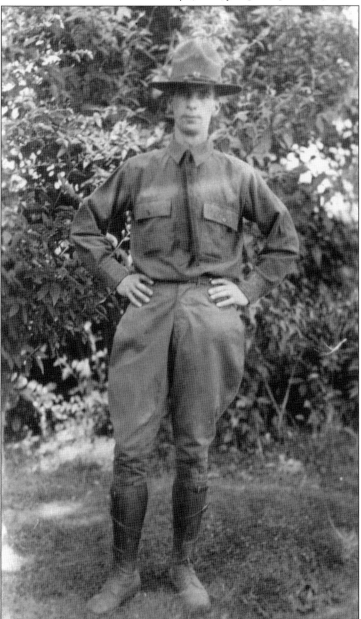

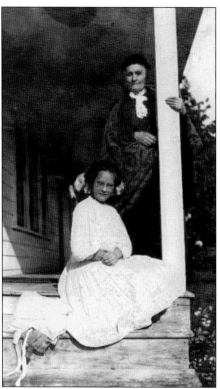

Olivia (French) Davis poses on the porch of the French house with her grandmother Caroline French shortly before Caroline's death in 1909. Caroline's husband, Samuel Foster, who went by "Foss," had died three years earlier. The French family had suffered financial losses in the 1890s after investing in Kirk's boom development, but by the late 1900s, things had stabilized through the sale of portions of their homestead claims.

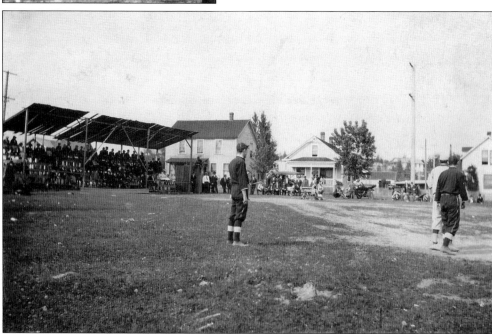

A nice-sized, predominantly male crowd showed up for this 1910s baseball game at the site of today's Heritage Park. The view faces north; Waverly Way is in the background, with a few early automobiles pulled off to the side. It was a much more formal era, as most of the spectators are wearing jackets and ties.

Four

OF STEAMBOATS, FERRIES, AND LANDINGS

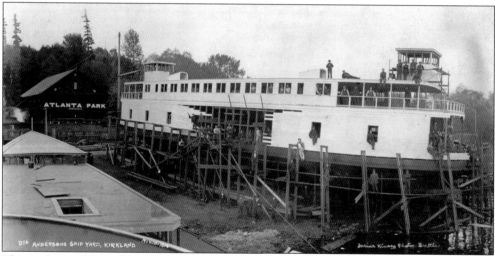

The Anderson Shipbuilding Company is seen here in November 1914. The ferry *Lincoln* is under construction, as is the steamboat *Dawn*, in the foreground. The shipyard was located in Houghton on the site of today's Carillon Point development. The Curtis family had owned the land and built the steamboat *Peerless* in 1901. They sold a section that year to captains George Bartsch and Harrie Tompkins, who built and operated steamboats under the B&T Transportation banner. In 1907, Capt. John Anderson bought controlling interest in the yard and the name was changed to the Anderson Shipbuilding Company. Anderson was already an established steamboat operation on the lake; he also operated excursion parks, such as Atlanta Park, which had been located above the yard—its dance pavilion can be seen here. The *Lincoln* would become the primary ferry to serve Kirkland up to 1940. The diminutive *Dawn* spent its career running between Leschi and the west side of Mercer Island.

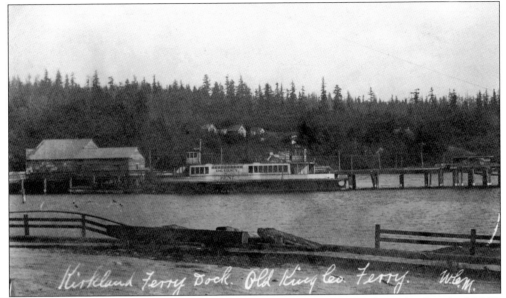

In this c. 1901 photograph is Kirkland's King County ferry slip, seen from the Standard Mill's wharf, which extended from the foot of Market Street. The ferry slip stood at the foot of Kirkland Avenue. The lake was nine feet deeper then, and much of the water seen here is dry land today. The county-owned ferry *King County of Kent* was plagued with problems from its launch in 1900, when it became stuck in the mud.

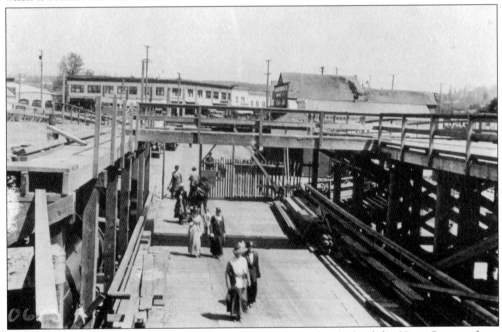

The ferry slip is seen here during 1912 renovations from the deck of the King County ferry *Washington of Kirkland*. Launched in January 1908, the *Washington* was constructed for $85,000 for the Kirkland to Madison Park run. Like its predecessor, the *King County of Kent*, the Washington was plagued with problems, both financial and mechanical, including "hogging" (arching in the center.) The *Lincoln*, launched in December 1914, was its replacement.

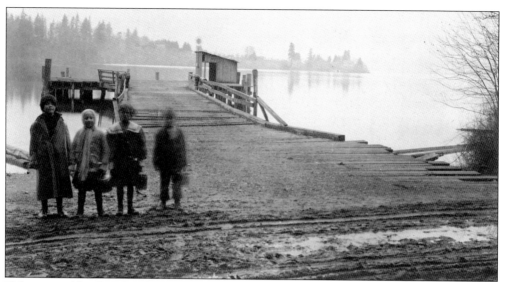

Kids pose at Northup Landing, clearly illustrating the origin of the terms "lunch bucket" and "lunch pail." Northup was a small community just south of Houghton, about where State Road 520 crosses Northup Way today. Though it is now a part of the city of Bellevue, it was historically associated with Yarrow Bay as its link to Seattle. The landing was left high and dry when the lake lowered in 1916. (KCA.)

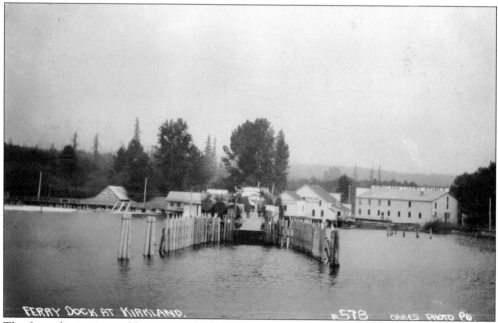

The ferry slip is pictured here around 1908. Due to the nine-foot-higher lake level, Lake Street (left) was literally built on pilings over the lake. The large oil tanks at the end of the slip were used to supply the ferry. Fuel was brought by rail to the Feriton Spur, today's Google campus on Sixth Street South, and hauled down the hill by wagon or truck to the dock, where it was laboriously transferred to the storage tanks.

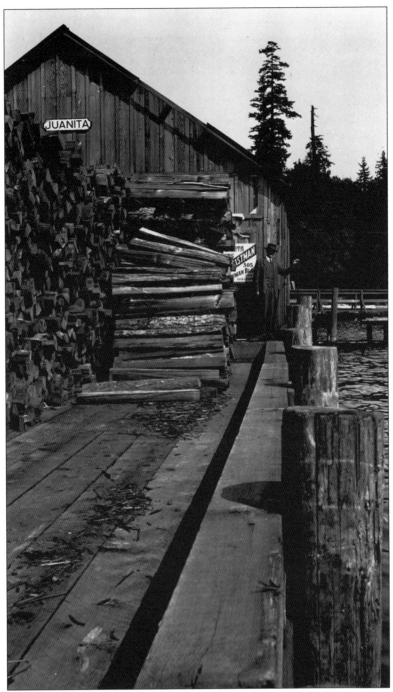

Early Juanita residents depended on lake transportation, so King County constructed dock No. 586, seen here looking east, about 1910 to facilitate private steamboats. Juanita could only accommodate steamboats, not ferries, and extended out from the northern end of the Juanita Bridge. The cordwood piled on the dock was used to fuel the steam boilers; Dorr Forbes and his sons frequently supplied cordwood under contract to the steamboat owners. The primary boat serving Juanita, the *Urania*, was owned by Capt. John Anderson. (KCA.)

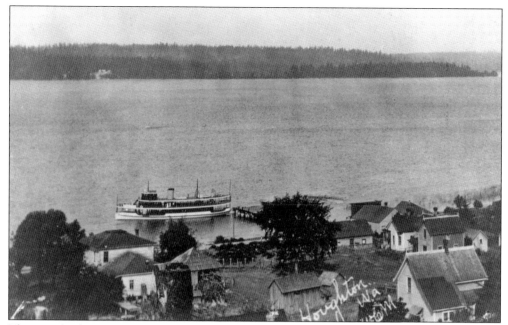

The site of today's Doris Cooper Houghton Beach Park is seen here in 1909. This was then called Houghton Landing; the steamboat leaving the dock is the *Urania*. Capt. John Anderson constructed the *Urania* in 1907 on property south of Madison Park. It primarily ran between Madison Park and the public and private docks between Juanita Bay and Yarrow Bay.

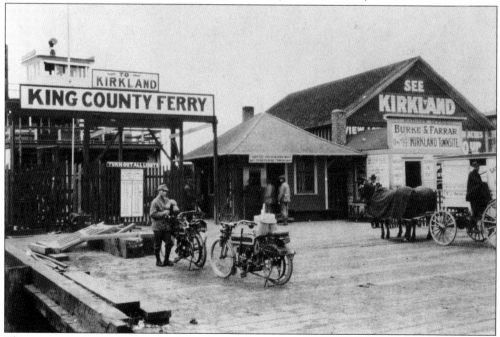

This is a c. 1910–1916 look at the King County ferry slip at Madison Park. The ferry visible is the *Washington of Kirkland*. The ticket office is in the center, and at right is the Burke & Farrar sales office, proudly proclaiming, "Burke & Farrar, Owners of the Kirkland Townsite." Madison Park remained Kirkland's Seattle steamboat and ferry connection until the last boat ran in 1950.

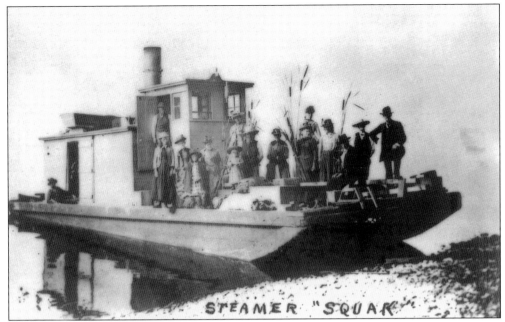

The *Squak* was the first steam powered vessel built on the lake. Capt. Frank Curtis is seen in the wheelhouse doorway. His son Capt. Walt Curtis took this c. 1889 photograph, and his brother Alvin is seen at far left in the engine room doorway. Also pictured are Peter Kirk's daughters Fanny, Olive, and Marie. The group had returned from a picnic in Juanita, where they appear to have collected some cattails.

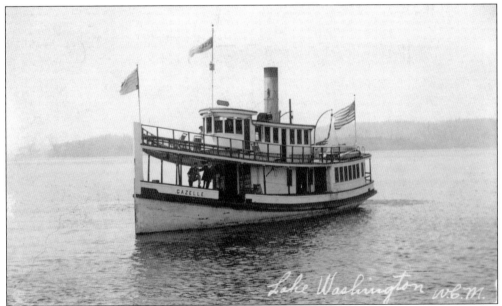

The *Gazelle* was a steamboat built in 1898. It was operated by Capt. George Bartsch individually, then under the B&T Transportation Company banner, and finally under Anderson Steamboat Company ownership. It was one of several early small Puget Sound steamboats laboriously brought up into the lake via the Black River. This process often took days and a great deal of physical effort, as the river was shallow, winding, and snag-strewn.

Cordwood is stacked and ready to go. According to his granddaughter the late Dorris (Forbes) Beecher, who provided this photograph, Dorr Forbes and some of his sons cut this wood, and the image was captured on their property, the northeast side of today's Juanita Beach Park. Steamboat operators had to make arrangements to keep a steady supply of wood available.

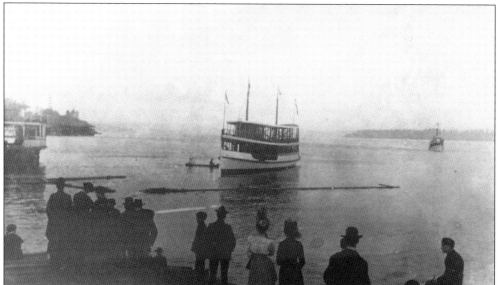

Capt. John Anderson launched the beautiful 81-ton, 107-foot steamboat *Fortuna* in 1906 on the lakeshore south of Leschi, near the foot of Jackson Street. Anderson had invested most of his savings and cash into the boat, used for both regular passenger service and excursions. The launch was successful, but not without mishaps. The boat slipped off the track and had to be jacked up with wedges.

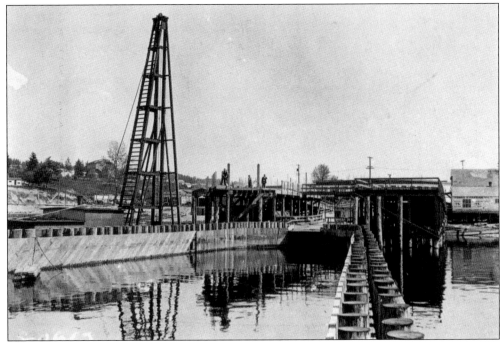

These two views of Kirkland's ferry slip were both taken during the 1912 renovations from the ferry *Washington of Kirkland*. Seen above at left, Central Avenue is right on the water and built up on pilings in places. At the far right, the Burke & Farrar sales office advertises lots for "$75 and up." The image below reveals that there was little development south of Kirkland Avenue. Note the billboard for Wrigley's Gum. Left of the ferry slip, the small structure on Lake Street was the real estate office of Reginald H. Collins, who came to town during the Kirk boom and stayed on. He was considered Kirkland's first mayor.

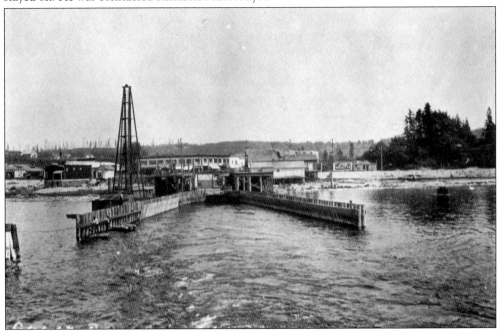

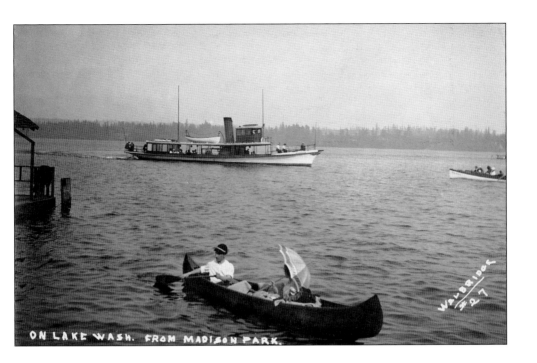

ON LAKE WASH. FROM MADISON PARK.

Pictured here are the steamboats *Xanthus* (above) and *Cyrene* (below). Capt. John Anderson bought the 94-foot yacht *Cyrene* in 1901 from Seattle pioneer industrialist James M. Colman. A short time later, he purchased a second yacht from Colman, the 83-foot *Xanthus* in 1903 or 1904. Anderson immediately adapted the steamboats to passenger service and brought them into service on Lake Washington. The two saw hard use on the lake. In 1914, both beloved vessels were dismantled—the *Xanthus's* steam engine was removed and placed into the stubby new steamboat *Dawn*, and the *Cyrene's* machinery was placed into the *Urania*, which had been rebuilt that year after a fire. Both hulls were filled with sand and scuttled by Capt. Frank Gilbert (son of Gilbert Hotel owners Elmer and Jeannie Gilbert) and rest on the bottom in about 150 feet of water off Carillon Point.

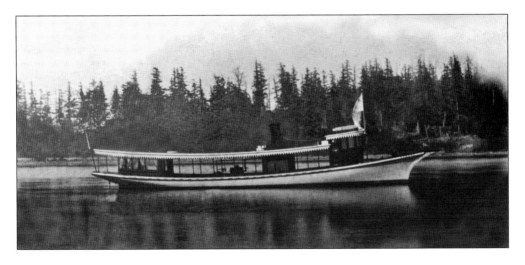

This is a 1914 photograph from the album of Olivia (French) Davis of her friend Antoinette Shumway. The shops at left were built by captains George Bartsch and Harry Tompkins after they started a boatyard on the site in 1901. The Atlanta Park dance pavilion was built in 1908, a year after Capt. John Anderson bought a controlling interest in the company. Anderson owned and operated several such private parks on the lake.

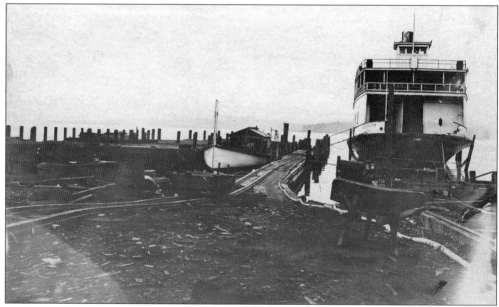

This is a c. 1910 rare look at the Anderson Shipbuilding Company. The facility was still quite small, and appointments were crude. The ferry *Washington of Kirkland* is on the ways; it appears to have sustained some gunwale damage, visible at the far right, and was likely undergoing repairs. The small tramway was used to transport heavy machinery between the ways and the shops.

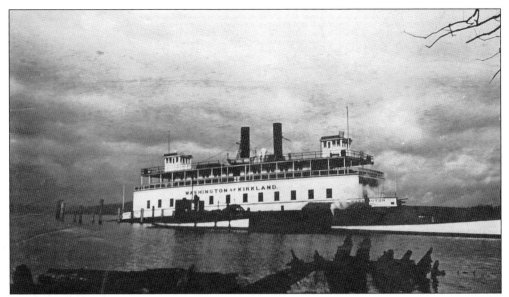

This is an additional look at the *Washington of Kirkland* on the ways undergoing repairs. After the steel-hulled *Lincoln* was launched in December 1914, the *Washington* stopped scheduled runs but was taken out of the lake onto Puget Sound and placed on the Vashon-Fauntleroy-Harper route. It was replaced in 1925 with the ferry *Kitsap* and returned to Lake Washington tie-up.

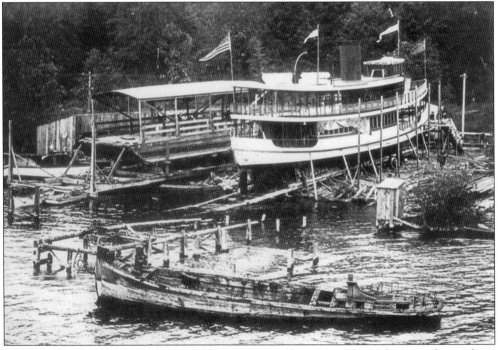

This is a picture of the Anderson Shipbuilding Company from 1908. The 95-foot steamboat *Atlanta* is on the ways. Anticipating the excursion business that the Alaska-Yukon-Pacific Exposition of 1909 would bring into the area, Anderson built a number of twin-decked excursion boats, including the *Triton* and *Aquilo*. The partially submerged hulk is the remains of the *Gazelle*. Its steam boiler had been salvaged to provide steam for the yard's equipment.

Prior to the opening of the Lake Washington Ship Canal and locks in 1916, the lake level fluctuated much more than it does today—the level is now controlled by the US Army Corps of Engineers using the locks. This is clearly a time of low water; the Kirkland ferry slip's ramp is at a much sharper angle than it was in the photographs taken during the 1912 renovations. (KCA.)

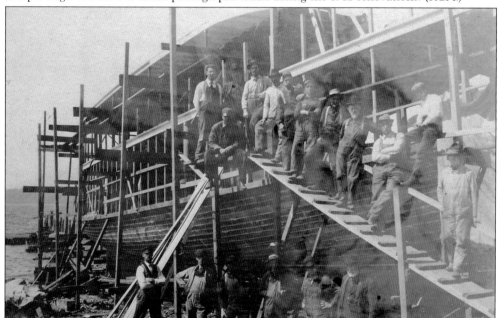

The 78-foot steamboat *Aquilo* is seen under construction in 1908; it was launched in May 1909 and scrapped in 1938. The yard was still quite crude in its methods; boats were constructed on the muddy shore without much more than scaffolding and skilled tradesmen working with their own hand tools. Boats were launched during flood season on the lake. At this time, there were no ways, and the extent of the yard's machinery was a mule-powered windlass.

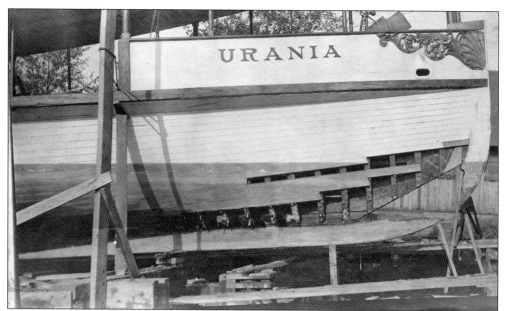

These close-up shots provide a detailed look at the work being done at the yard in addition to constructing new vessels. Dry rot was a chronic problem on the lake; in the image above, the *Urania* has been hauled out to replace some planks and portions of its keel. The detail of the hand-carved decorative wood is impressive. One of the boat's kedge anchors is visible, lashed to the gunwale near the carving. The *Cyrene*, seen at right, was lengthened to 100 feet in 1903 at Atwood's Wharf, just north of Leschi. This c. 1908 shot of the boat was taken at the Anderson yard while it was probably in for general maintenance after modification. In the background is the 1908 version of a Porta-Potty: an outhouse positioned over the lake.

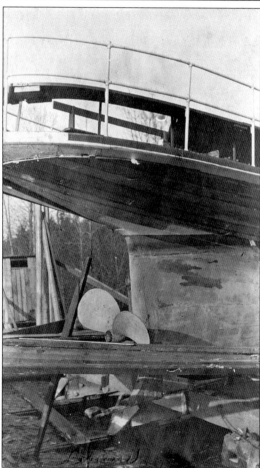

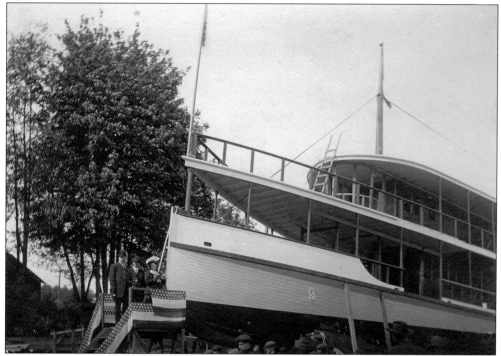

The image above shows the *Urania*'s launch on May 11, 1907, at the Lake Washington Mill Company near Leschi. The young woman ready to christen the boat was Daisy Johnson, daughter of E.E. Johnson (left) of Seattle Machine Works, the company that installed the boat's machinery. Captain Anderson is in the center. Below, the *Urania* is seen underway on the lake.

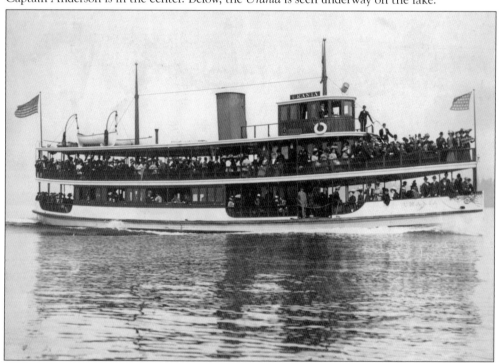

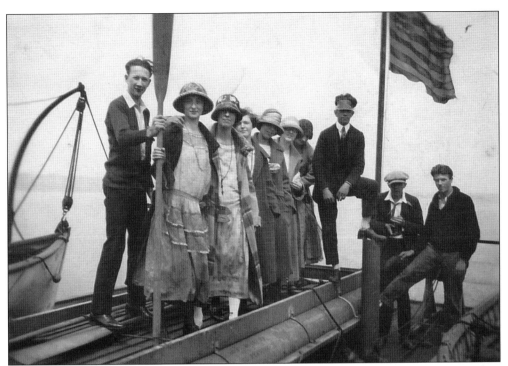

These are two candid shots of Kirklanders enjoying a trip on the *Urania*. Above, Juanita resident Alice (Ostberg) Johnson (holding the oar) and several of her Kirkland High School classmates pose at the stern on the upper deck, standing on the life raft. Below, members of the Robert and Lucy Barrie family enjoy each other's company and snacks at the stern on the main deck as they cross the lake. (Above, McAuliffe family; below, KHS.)

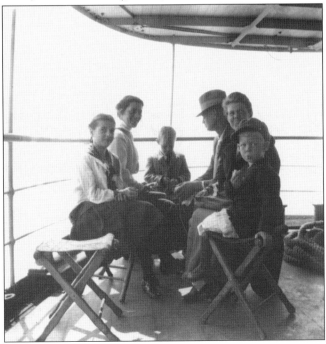

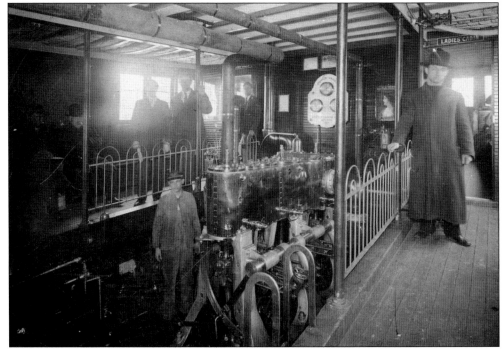

The *Urania's* engine room is seen here. Visible on the wall surrounding the gauges is the builder's plate. Women were offered their own cabin (to the right). Safety standards then were very lax compared to today. An engineer named E.C. Clayton was once oiling the engine when it turned over and chopped his arm off below the elbow. After healing up somewhat, he returned to the same job on the boat with only slightly diminished capacity.

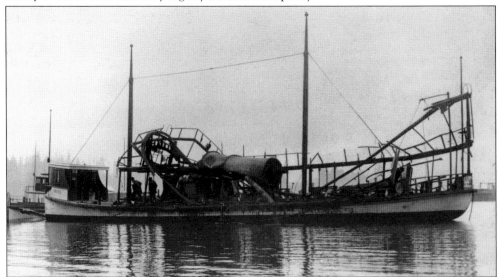

By the 1910s, the automobile was here to stay, so in 1913, Anderson modified the *Urania's* bow to accommodate four cars loaded perpendicularly. Not long after that, the beautiful boat caught fire at Houghton in February 1914. Capt. Frank Gilbert, later the longtime skipper of the *Dawn*, chopped the forward section off using a crosscut saw and rebuilt it as a 59 footer with an engine from the *Cyrene*.

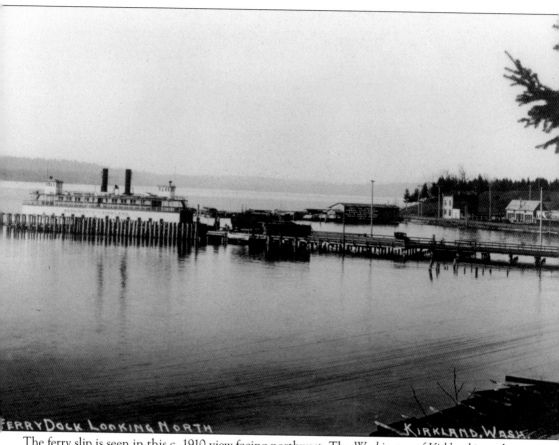

The ferry slip is seen in this c. 1910 view facing northwest. The *Washington of Kirkland* is at the slip, and the Hewlett Lee Lumber Company wharf extends from the foot of Market Street. The brick 1888 Bank Building at the foot of Market Street then housed the Kirkland State Bank, and to its right is Elmer Gilbert and Carl Knauf's blacksmith and auto shop. The lake comes right up to Central Avenue.

By the 1910s, it became clear that Lake Washington's transportation future lay in car ferries, not steam or oil passenger boats. Anderson built the 114-foot *Issaquah of Mercer Island* in 1914 for the Leschi–Roanoke–Parental School–Newport run (Roanoke and Parental Schools were on Mercer Island). It had a hardwood dance floor for excursions and could carry 40 cars and 600 passengers. It was sold after three years, unable to compete with the King County–subsidized ferry *Leschi*.

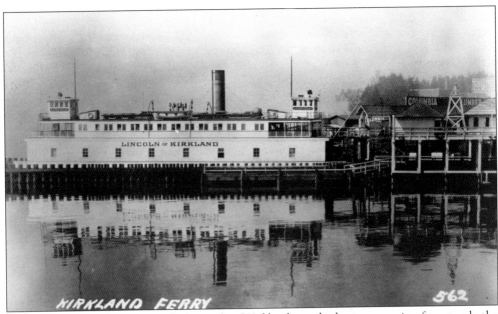

King County's 147-foot, steel hulled *Lincoln of Kirkland* was the longest running ferry to ply the Kirkland–Madison Park route. Launched on December 2, 1914, the boat ran on Lake Washington until 1945, the last few years making special trips for shipyard workers during World War II. This image dates from the 1930s. The ferry slip is in its final configuration and Kirkland High School is visible on the hill to the right.

Probably no single event had more impact on early Kirkland and Lake Washington than connecting the lake to Puget Sound in 1916. The Black River, which had previously drained the lake, became extinct, and the Cedar River was rerouted to flow into the lake. By lowering the water level nine feet, some aquatic plants were wiped out, like the wapato, and docks were left high and dry. Canal construction began about 1911. Above is a 1913 photograph of construction activity at what would become the Montlake Bridge. Below is the final cut as the water from Lake Washington began rushing out and draining into Portage Bay. (Both, SMA.)

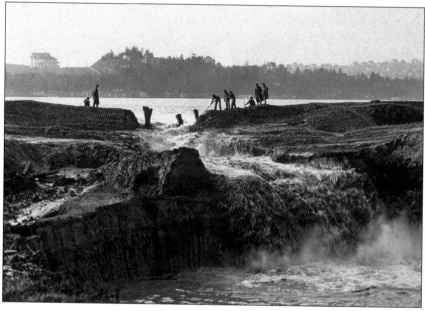

The crew of the *Lincoln* is pictured here around 1925. This image came from Jan (Etzler) Strode, granddaughter of Earl Eltzer, one of the *Lincoln*'s pursers, seen in the first row, fourth from the right. One of the boat's captains, pioneer steamboater Walt Curtis, is at the far right. One of the engineers was Herb Brooks, though it is uncertain which man in the photograph is him.

Access to the sea brought big changes to the Anderson Shipbuilding Company. It quickly went from a rather primitive yard turning out smaller passenger boats and ferries for lake use to building much larger ocean-going craft. One such early big contract was for the 1918-launched ocean-going steamer *Osprey*, built for the French government.

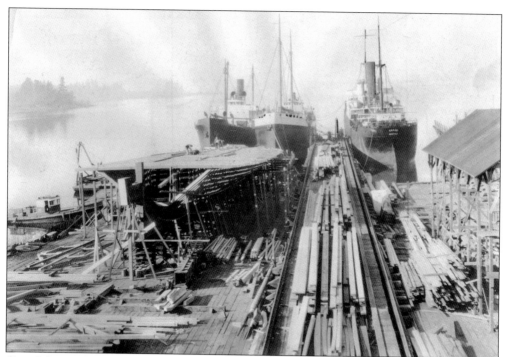

Capt. John Anderson sold the Anderson Shipyards to Charles Burckhardt in 1923. Anderson was managing the Lake Washington ferries for King County and was involved in Puget Sound too. Burckhardt was a major salmon packer. He changed the yard's name to the Lake Washington Shipyards and began to also use the facility as winter tie-up for Alaska fishing vessels and cannery tenders. This is the Lake Washington Shipyards in 1926.

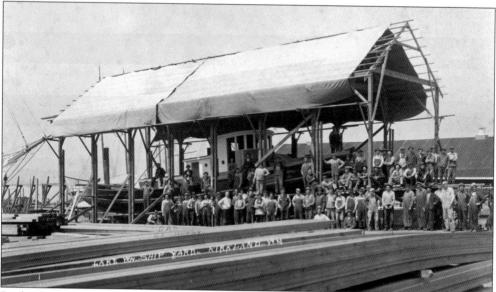

By the 1930s, the Lake Washington Shipyards had changed dramatically from its humble origins a few decades earlier. While the Great Depression brought hard times for most area residents, the shipyard offered steady paychecks to many Kirkland and Houghton residents. Here, the men are gathered around a nearly completed tug in a photograph from 1930.

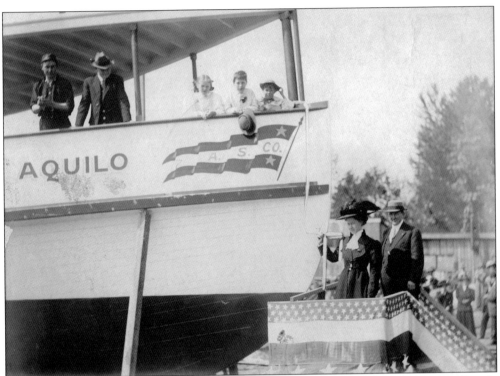

Capt. John Anderson was a Swedish immigrant who first went to sea at age 14. He came to Seattle about 1888 with $20 and crewed on Puget Sound work boats until taking a job on the lake steamboat *C.C. Calkins* in 1890. Within a few years, he purchased half interest in the *Winnefred*, and then bought his own boat, the *Quickstep*. Captain Anderson is seen above on the platform at right with his wife, Emilie (Matson) Anderson. He added boats and related businesses to his empire, and by the 1920s, was running King County's Lake Washington ferry system. Even after auto ferries had taken over water transportation, he still operated his passenger boats in the excursion business through the 1930s. In 1935, he donated a recently restored ferry clock to the people of Kirkland that still stands on Kirkland Avenue. He died in 1940 but still has relatives living in Kirkland today.

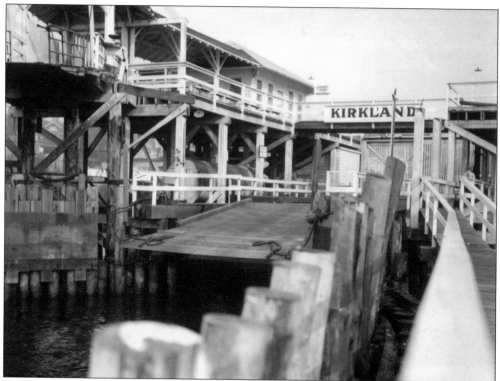

Kirkland's King County ferry slip had also come a long way by the mid-1930s from its humble origins three decades earlier. The passenger waiting area is seen above at center left on the second level. The tanks beneath that were oil holding tanks used to fuel the *Lincoln*. The sign above, near the waiting area, advertises stages. Passengers walking off had options of cabs or scheduled stages to Redmond and other communities. (Both, KCA.)

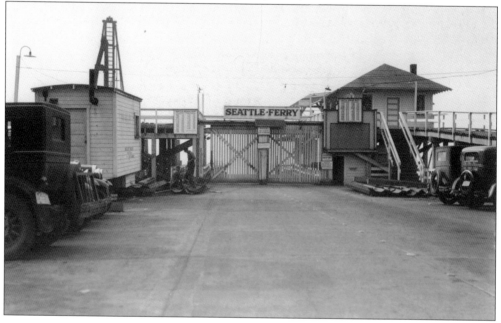

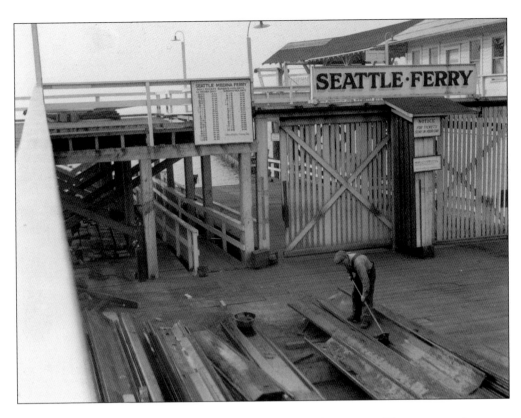

Seen here are two more shots of the ferry slip, this time facing west. The sign at right warns passengers, "For tickets remain in your car." The photographs were taken by King County prior to some work being done; in the foreground are sections for cofferdams.

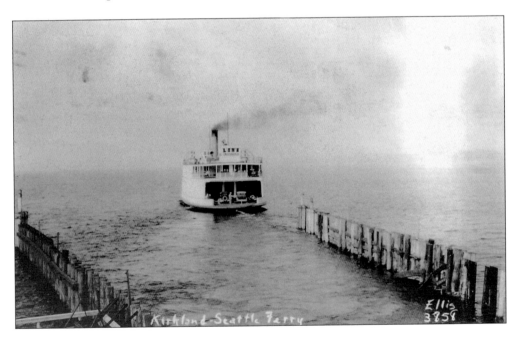

Five

BETWEEN THE WARS

Young George Williams shows off his skills as an axman around 1925. George lived with his family off Seventh Avenue, just east of the railroad tracks. His father, John "Johnny" Williams, owned the Rose Hill Fuel Company, which supplied area homes with firewood and coal. George graduated from Kirkland High School in 1939 and went on to join the Kirkland Police Department (KPD), rising to the rank of sergeant. He left KPD in the early 1960s after working with the chief to expose a widely publicized police corruption scandal. He went on to a career with the Boeing Company. (Doug Williams.)

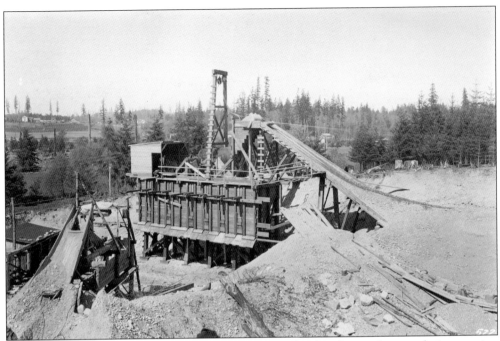

The City of Seattle purchased a portion Marit Josten's land and started a gravel pit operation there in 1919. The gravel was taken by truck to a wharf extending from the Juanita Bridge, loaded onto barges, and then towed to various points in Seattle for use in road construction. These shots were taken in 1919; the machinery was located on the hill about where the Juanita High School tennis courts are today. The view above faces north toward NE 132nd Street. The view below looks northwest and provides a look at the Juanita School at the intersection of 100th Avenue NE and NE 132nd Street. The home visible to the right of the school belonged to Andrew Nelson. Big Finn Hill shows second growth about a decade or two old and some remaining tall first growth. (Both, SMA.)

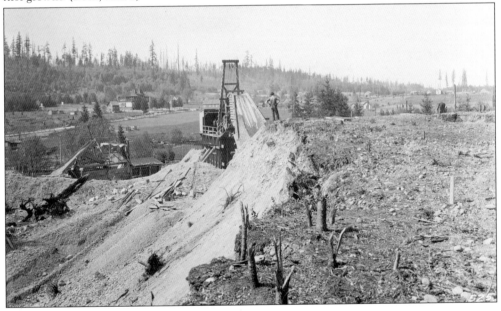

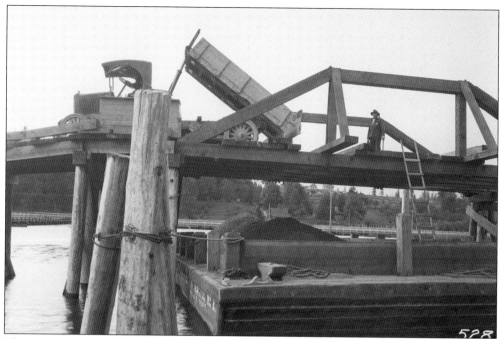

The Seattle Street and Sewer Department gravel wharf is still visible today as piling ruins extending out from the Juanita Bridge, but these 1919 images show it in use. Above, an early dump truck deposits its load into a barge. The view faces east toward the Juanita Bridge, and NE 112th Street is visible just above the gravel load. To the right of NE 112th Street, a former causeway to the pre-1916 Juanita Bridge sits high and dry. The view below faces south, the road into Kirkland that becomes Market Street is at left, and today's Juanita Bay Park is the undeveloped property on the water at right. (Both, SMA.)

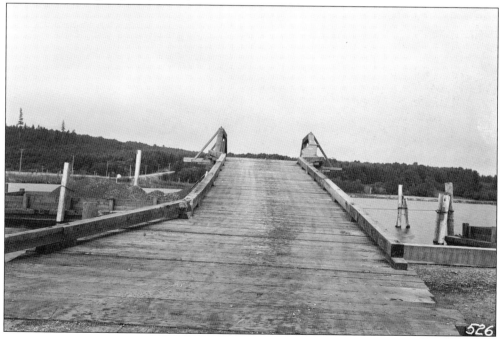

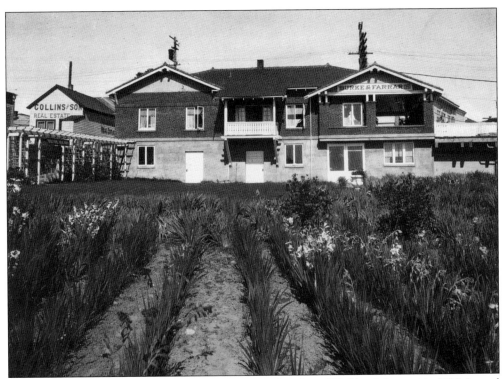

Burke & Farrar erected the building at 1 Lake Street South and Kirkland Avenue in 1918. It used the upper floor as company offices and, in the basement, launched the *East Side Journal* newspaper, which, until 1976, served as Kirkland's popular hometown newspaper. William Sherbrooke planted flower beds in the fertile, former lake-bottom soil behind the building, and his son Charles sold cut flowers to the ferry passengers. These flowerbeds are now under the Marina Park parking lot. The view above faces east, and the building stands today, though enlarged substantially. The other c. 1918 shot below, taken from Lake Street, looks south during street repairs.

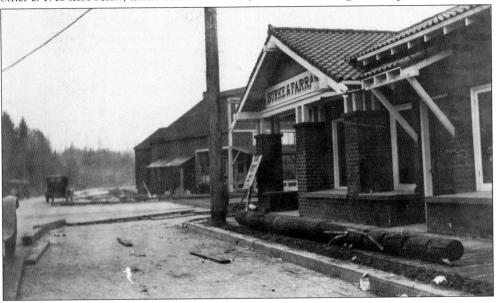

This view looks south down Market Street in the 1910s. The Brooks Building, at 609 Market Street, still stands today. This photograph was taken during a street and sewer renovation; it was not normally this narrow, nor did it have open gutters.

More 1910s street renovations are taking place here; Lake Street South is having new concrete slabs poured. To the right is the intersection of Lake Street South and Kirkland Avenue. In this view, the pilings supporting the buildings on the west side of Lake Street South are quite prominent. The building at left has "Burke & Farrar" written across the roof.

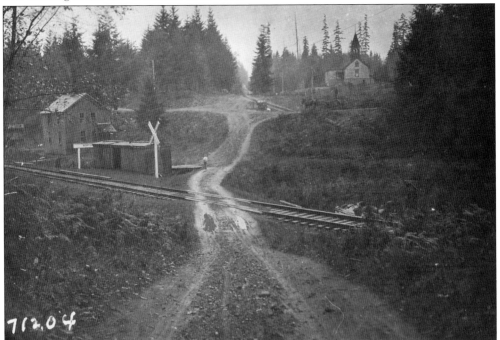

While not a part of Kirkland, what is now the Bellevue neighborhood of Northup was originally closely associated with Houghton. The camera faces east-northeast, Northup Way runs across the Northern Pacific tracks through the center, and the cross street is 116th Avenue NE. The building is the old Northup School, which was built in the 1880s and is still standing today. In the early 1900s, the Northup, Houghton, and Kirkland Schools were consolidated into a single district called Union A.

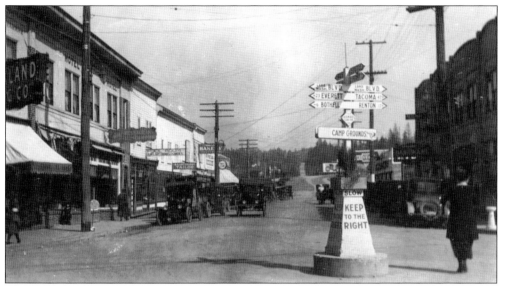

This view look up Kirkland Avenue at Lake Street around 1925. The building at far left had many uses over the years, including as a drugstore, hotel, Burke & Farrar offices, and a small section that even served as an early hospital. Kirkland Avenue was then the route to Redmond from Kirkland, and the other route was out of Houghton via NE 52nd Street, then called Curtis Road; the two met at Old Redmond Road.

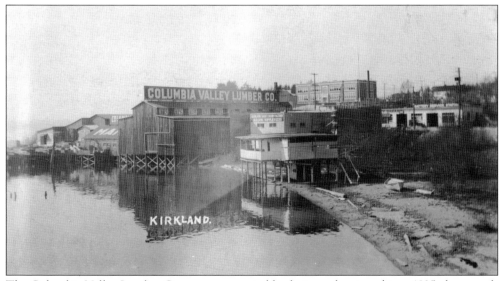

The Columbia Valley Lumber Company was a sizable chain at the time this c. 1925 photograph was taken, and Kirkland was one of 16 locations. The lake was lowered nine years earlier, but the water came up much farther than today, illustrating the extent of the fill required to create Marina Park. The brick building at center right was the Union "A" High School, built in 1923 and informally called Kirkland High.

Blau's Garage stood on the northwest corner of Kirkland Avenue at Main Street. According to the late Arline Ely's 1975 book *Our Foundering Fathers*, Blau's served as the storage facility for firefighting equipment and as the city's earliest jail—it had two cells in the back, next to the fire equipment. The Blaus were avid baseball players, and their business also doubled as early Dodge and Chevrolet agencies. From 1923 until the 1940s, the Kirkland Laundry, seen below, was owned by Daniel Larson, a Swede who immigrated in 1901.

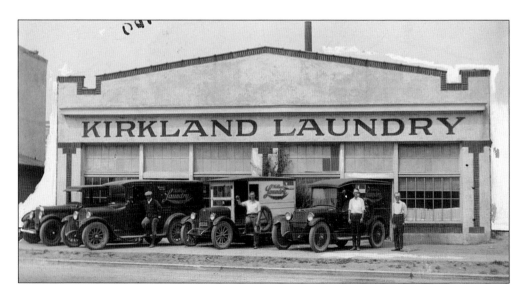

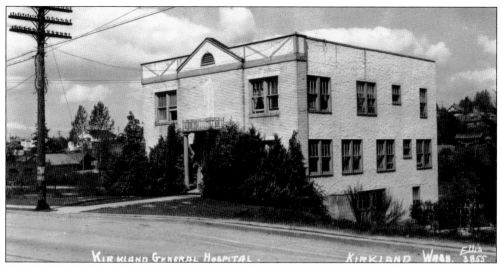

The Kirkland Hospital opened in 1930 on Kirkland Avenue at Third Street. Its first patient was Lake Washington Shipyard worker William Davis, who had a steel fragment lodged in his jaw. The hospital was expanded in 1951 but finally closed in March 1971, replaced by Evergreen Hospital. The Kirkland Hospital's final patient, Clara Davis, was taken out to a nursing home. William Davis, the hospital's first patient 40 years earlier, was her son.

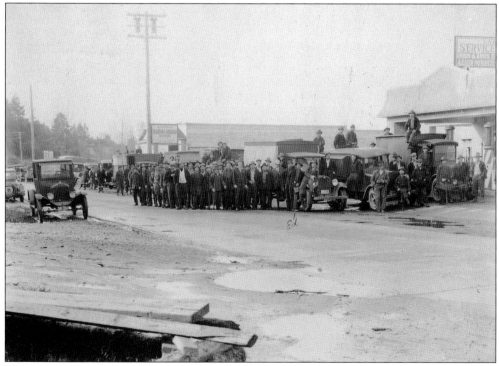

The purpose for all this hubbub at Lakeside Service Station is not recorded, but it was quite a turnout. These were not mere gas stations, but establishments where employees checked fluids, tire pressure, cleaned off the windshield, and offered a slew of other services. Lakeside Service Station was built on prime waterfront property on the west side of Lake Washington Boulevard at roughly Second Avenue South, then called Jackson Street.

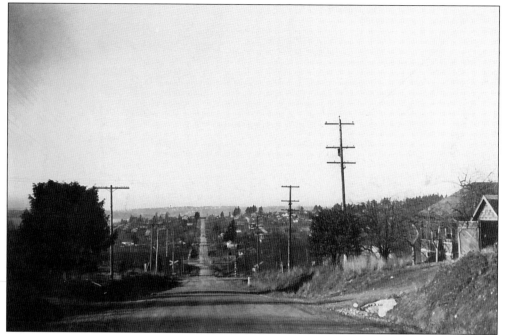

John and Nettie Williams lived with their three children Clarence, Charlotte, and George on the north side of Seventh Avenue/NE Eighty-Seventh Street between 112th and 114th Avenues NE, on land he also used for his business, Rose Hill Fuel Company—which sold firewood and coal. The view above looks west down Seventh Avenue. Then called Piccadilly Avenue, it was originally planned as the primary thoroughfare connecting the steel mill to the envisioned business district on Market Street. Photographed around 1923, the Northern Pacific Railroad tracks are clearly visible, as is a sparsely developed Norkirk Neighborhood—most of the vacant lots were offered for sale at easy terms by Burke & Farrar, however. The image below is of the three Williams kids (George is the youngest) on the family property on a snowy day in 1925. The camera faces northeast toward Rose Hill. (Both, Doug Williams.)

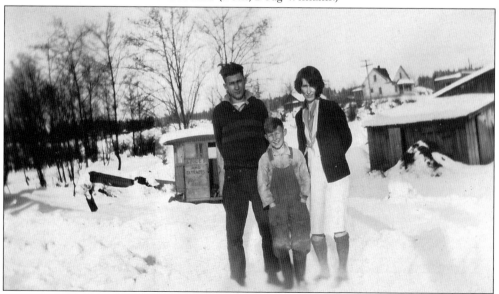

The Union "A" High School at Kirkland, later simply Kirkland High School, was built on a somewhat awkward hillside in 1923, with a graduating class of about 25 kids. With Kirkland's population at around 1,500, the old 1904 Central School had become too small. Students entering high school came from Kirkland and the neighboring communities of Juanita, Rose Hill, Houghton, Northup, and the Points. It became Lake Washington High School in 1945, and when the new high school was completed in 1949, it became Terrace Hall of the Kirkland Junior High School complex, up through its 1973 destruction from a fire. The terraces did not come naturally—they were created to manage the steep hillside. John Williams, below, also did road construction and was hired to help shape the roads with his steam roller. (Above, KHS; below, Doug Williams.)

This is another shot of John Williams with youngest son George taking a break from building the terraces, posing with their small Iroquois steam roller. Market Street is behind them, and the old Central School is partially visible between the houses. Portions of the terraces John Williams leveled are still visible today as part of Heritage Park. The image below was taken around the same time from a similar angle, only directly east, giving a wider, clear look at the old Central School and Kirkland Congregational Church. There were still plenty of vacant lots for sale in the Norkirk neighborhood then. There still were not many trees, but of the few there are, the taller ones would have been about 30 years old, as second growth from after the Kirkland Land & Improvement Company undertook its massive clearing of the area around 1889. (Both, Doug Williams.)

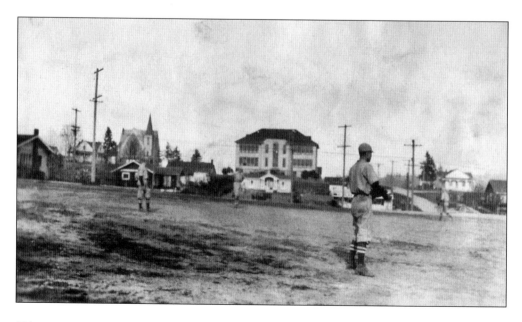

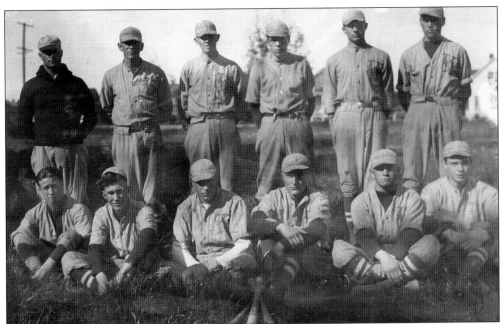

Seen here is a slice of Kirkland sports between the wars; above is Kirkland's baseball team, one of many semipro clubs in the area. The games with other communities' clubs were typically fairly well attended and received considerable coverage in the sports pages of *The Seattle Times* and *Seattle Post-Intelligencer*. Waverly Way is in the background. The young ladies in the image at right play tennis on a court at the Central School. (Both, Doug Williams.)

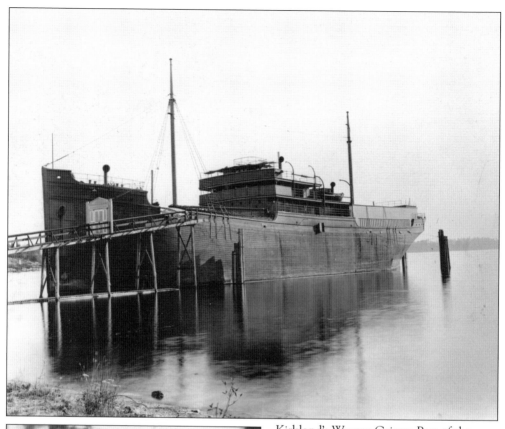

Kirkland's Warren Grimm Post of the American Legion formed in 1919 and was a popular organization in the 1920–1930s. Most Kirkland World War I veterans were members. Post leaders obtained one of the nearly 50 surplus *Ferris*-type wooden freighters stored on Lake Union and tied it up at the foot of Second Avenue South, then Jackson Street. Named *Fort Jackson*, the vessel served as the post clubhouse until 1929.

Even inside of the town limits, home life in Kirkland was bucolic in the 1920s and 1930s. Etzler brothers Earl Jr. (left) and Henri were enjoying pedal car and tricycle riding in their driveway until dad, Earl Sr., stopped them for a quick snapshot. (Jan [Etzler] Strode.)

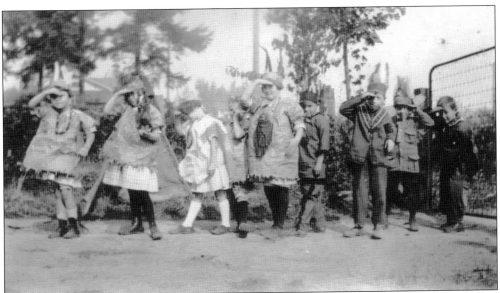

The Etzler kids and their classmates from the Central School pose in Thanksgiving-themed costumes around 1925. (Jan [Etzler] Strode.)

This c. 1930 look at the Northern Pacific Railroad's Kirkland freight station includes a locomotive on the tracks. The concrete Bridge No. 17 was built in 1927 over Kirkland Way and is still in use today, complete with a distinctive Northern Pacific Railroad logo painted over 75 years ago on its southeast abutment. Kirkland Avenue is visible behind Kirkland Way and crosses the tracks at grade next to the station.

One of the saddest events occurring in Kirkland between the wars was the murder of 14-year-old Letitia "Letty" Whitehall of Rose Hill. On Saturday, October 30, 1926, Letty left the dental office of Dr. Chester Dobbs, pictured at right, and was not seen alive again. By the next day, her parents, George and Mabel Whitehall, were frantic and enlisted the public's help in their search, but to no avail. Her body was found on November 14, floating in the Sammamish River near Kenmore. Dr. Dobbs was arrested for the crime, but the evidence against him was weak, and he was acquitted after brief deliberations. Several men and boys were questioned and appeared as witnesses, but the well-publicized investigation by the King County Sheriff's Office was highly criticized, and the case remains unsolved. (Above, Tom Hitzroth; right, Ryseff Collection, KHS.)

Pacific Coast Bureau.

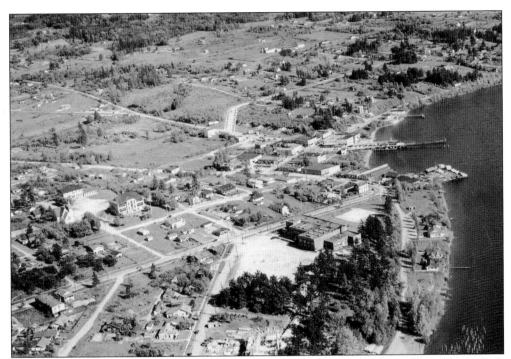

This view of Kirkland from the air in 1932 looks toward the southeast. The Kirkland Junior High School, later Waverly Hall, is seen at bottom center under construction. Its entry arch was saved after demolition and moved to the Market Street entrance to Heritage Park. There is a building on what is today the city parking lot at the northeast corner of Lake Street and Park Lane; it was formerly a Ford dealership.

Juanita's Anna Ostberg, second from left, is pictured in the 1930s. Baseball games were held on her land, and she would offer very popular chicken dinners for sale to attendees. Widowed with three children at age 35, Anna worked hard to support her family, holding various jobs over the years for the Juanita School District 21, including school custodian, driving kids to school in a horse-drawn wagon, and even district superintendent. (McAuliffe family.)

Les and Alicia Forbes are seen here with daughters Dorris (left) and Joyce in 1927. After the lake lowered, a sandy beach was revealed east of Juanita Creek. In 1921, Les and Alicia built a bath house, creating Juanita Beach, a resort beach on the narrow Forbes property. It became a popular seasonal destination, as were the adjoining Sandy and Shady Beaches, later consolidated as Shady Beach. Featuring elaborate diving platforms, high slides, and dance halls, Juanita and Shady Beaches had friendly competition as each added customer-attracting amenities. Juanita Beach Cabins adjoined Juanita Beach on the east. It was a separate business, but Les managed it for many years. Alicia and the kids performed many of the weekday operational tasks, and Les held a bailiff position with King County Court judge Reah Whitehead, one of the first women on the King County bench. (Both, Forbes Collection of KHS.)

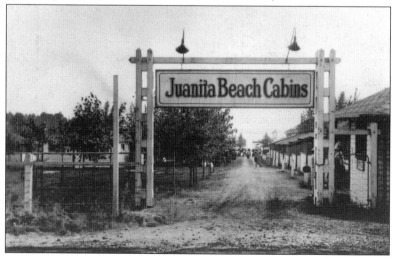

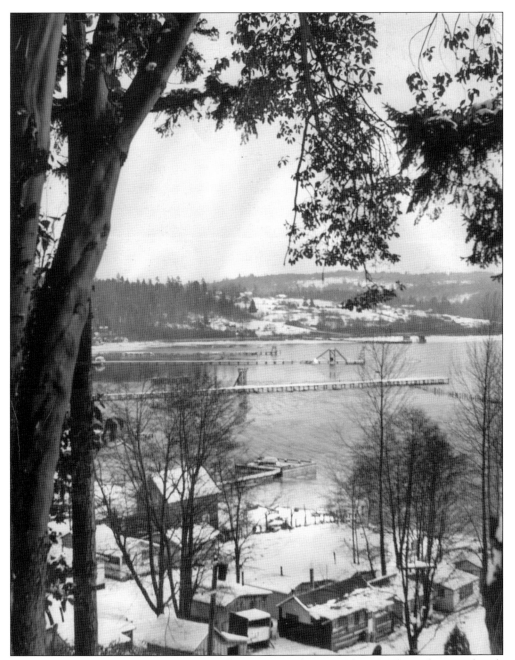

This photograph was taken from Goat Hill on a snowy day around 1930. The early resort beach piers stretch far out into the shallow bay, and Juanita Bridge and the gravel wharf are at the east edge. Little Finn Hill is behind that, and Rose Hill is in the far distance. This view looks east, and the Forbes's small first bathhouse is at far right. In the distance, NE 116th Street is stretching up the hill, and Harry Langdon's Juanita Grocery is just left of it. The other wood buildings were Langdon's as well.

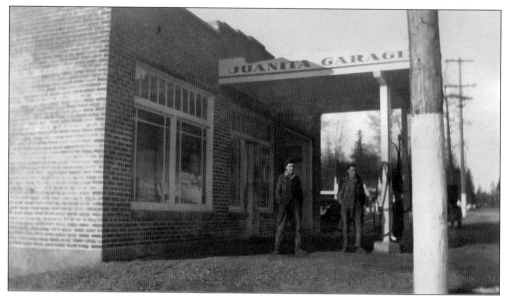

Harry Langdon's Juanita Garage, seen here around 1927, was located at Juanita Junction, at the southwest corner of NE 116th Street and 100th Avenue NE. Langdon built the brick shop after having operated in that location in a wooden structure since the 1910s. The view faces north, up 100th Avenue NE, a street that was not cut through until 1916.

Orion O. Denny (1853–1916) was the first white boy born in Seattle and son of Seattle cofounder and Peter Kirk steel venture investor Arthur A. Denny. O.O. Denny Park began as the 49-acre country estate named Klahanie, Chinook for "out of doors." After his death, the Denny family donated the land to the City of Seattle for a city park, though it was located in unincorporated King County. It opened in 1922. O.O. Denny Park's lifeguards are seen here about 1936. (SMA.)

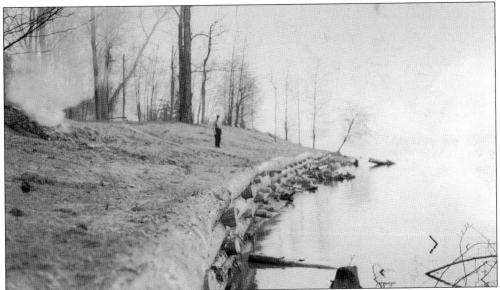

During the Great Depression, Pres. Franklin Roosevelt created the Works Progress Administration, later called the Works Projects Administration. Among other things, it put unemployed laborers on the government payroll doing various infrastructure improvements. Widely derided by many Kirklanders as lazy workers who were paid for "shovel leaning," it supported a few Kirkland area projects, including this 1936 log seawall at O.O. Denny Park. (SMA.)

Seen here in the 1930s, this house was the Orion O. Denny family's summer home at their estate they named Klahanie. Once the land became O.O. Denny Park, it was used as a caretaker's residence until it was demolished in 1955. (SMA.)

A big part of O.O. Denny Park's early mission was as Camp Denny, an overnight camping facility for Seattle kids, many of whom were underprivileged. O.O. Denny Park is still owned by the City of Seattle; the Denny family stipulated that it be used as a park into perpetuity or title would revert to the Seattle Children's Home Society, which has stated it would sell the land for development. (SMA.)

About the Kirkland Heritage Society

The Kirkland Heritage Society began as the Kirkland Historic Commission in 1977, a group whose primary focus was related to Kirkland's older homes. After falling into a hiatus for quite a few years, the organization was refounded in the early 1990s and its mission expanded "to identify historic resources; to encourage their preservation; to collect, preserve, exhibit and interpret the history and heritage of Kirkland and its people; and to promote public involvement in and appreciation of its heritage and cultures."

The Kirkland Heritage Society works for the preservation of Kirkland's remaining historic sites and to interpret the rich history of Kirkland and its people. Its monthly meetings are free and open to the public and feature programs of historical and related community interest. *Blackberry Preserves* is the monthly newsletter of the society and a valuable contribution to the body of knowledge of Kirkland's past. In 1994, it won an award from the Washington Trust for Historic Preservation. The Kirkland Heritage Society's Resource Center in the lower level of Heritage Hall at 203 Market Street is open to the public at various times during the week and by appointment. It contains the vast archive of images, artifacts, and ephemera amassed over the decades.

The society is also dedicated to Kirkland having its own historical museum in the near future. For more information please visit kirklandheritage.org.

DISCOVER THOUSANDS OF LOCAL HISTORY BOOKS FEATURING MILLIONS OF VINTAGE IMAGES

Arcadia Publishing, the leading local history publisher in the United States, is committed to making history accessible and meaningful through publishing books that celebrate and preserve the heritage of America's people and places.

Find more books like this at
www.arcadiapublishing.com

Search for your hometown history, your old stomping grounds, and even your favorite sports team.